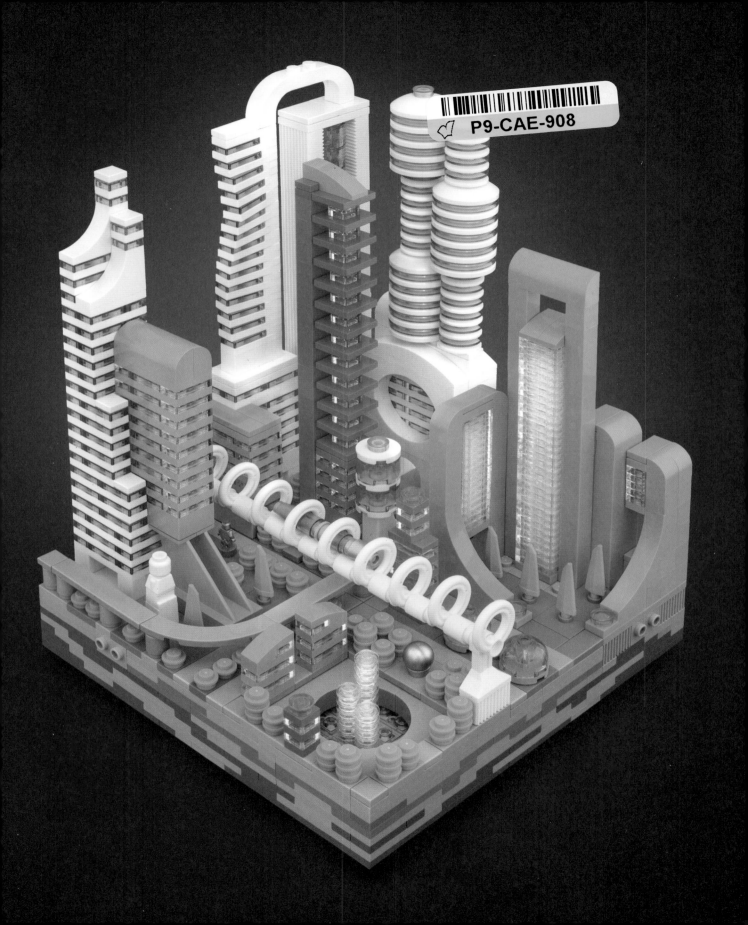

P9-CAE-908

PRAISE FOR
LEGO® MICRO CITIES

"This book is a LEGO dreamer's dream on a very small scale."

—JENNY BRISTOL, GeekDad

"Expert LEGO designer and builder Jeff Friesen presents an amazing book for LEGO fanatics, architecture fanatics, and anyone who enjoys building things."

—THE AWESOMER

"Building on such a scale is a challenge on its own, but making whole cityscapes? It's LEGO art at its finest."

—BRICK PALS

"Just flicking through its pages will have you looking at LEGO elements in completely different ways."

—ADAM WHITE, BricksFanz

"If you want to take your LEGO builds to the next level and really get a feel for how to design on the Micro scale, then this book has a lot of examples, ideas, and instructions to get you on your way."

—J.R. NIP, Game Vortex

LEGO® MICRO CITIES

BUILD YOUR OWN MINI METROPOLIS!

Jeff Friesen

SAN FRANCISCO

Printed in China

Third printing

25 24 23 22 3 4 5 6 7 8 9

ISBN-10: 1-59327-942-6
ISBN-13: 978-1-59327-942-4

Publisher: William Pollock
Production Editor: Serena Yang
Cover and Interior Design: Jeff Friesen
Developmental Editor: Annie Choi
Copyeditor: Rachel Monaghan
Proofreader: Emelie Burnette

For information on distribution, translations, or bulk sales,
please contact No Starch Press, Inc. directly:

No Starch Press, Inc.
245 8th Street, San Francisco, CA 94103
phone: 1.415.863.9900; info@nostarch.com; www.nostarch.com

Library of Congress Cataloging-in-Publication Data
Names: Friesen, Jeff (Photographer), author.
Title: LEGO micro cities : build your own mini metropolis! / Jeff Friesen.
Description: San Francisco, CA : No Starch Press, Inc., [2019].
Identifiers: LCCN 2018025695 (print) | LCCN 2018026052 (ebook) | ISBN
 9781593279431 (epub) | ISBN 1593279434 (epub) | ISBN 9781593279424 (print)
 | ISBN 1593279426 (print) | ISBN 9781593279431 (ebook) | ISBN 1593279434
 (ebook)
Subjects: LCSH: Miniature cities and towns. | Architectural models. | LEGO
 toys. | Cities and towns--Models.
Classification: LCC TT178 (ebook) | LCC TT178 .F75 2019 (print) | DDC
 688.7/25--dc23
LC record available at https://lccn.loc.gov/2018025695

My amazing wife, Tetjana, and
our daughter, June, are the source
of everything good in my life,
including this book.

ABOUT THE AUTHOR

Jeff Friesen is an award-winning photographer and LEGO enthusiast whose work has been exhibited in the United States, Canada, Europe, and Japan. He posts his popular LEGO photography on Instagram (@jeff_works), and in 2017, he was awarded the Brothers Brick LEGO Creation of the Year. Jeff lives in Victoria, British Columbia, Canada.

Contents

Preface

In this book, you'll discover how to build a dazzling LEGO city that you can hold in your hands. Once you unlock the potential of microscale building, you'll be able to create a miniature metropolis complete with skyscrapers, infrastructure, parks, and monuments—all inside an area just over 6 square inches. Rome wasn't built in a day, but your LEGO micro city can be!

LEGO microscale building techniques rely far more on the imagination than on having a large pile of bricks at your disposal. In the pages ahead, you'll learn many different ways to make buildings whose components can fit into an espresso cup. You'll also learn how to reimagine minifigure accessories as architectural ornaments. You'll soon see that building with LEGO is much more than stacking bricks on top of each other.

"Simplicity is the ultimate sophistication" is a quote often attributed to Leonardo da Vinci, and although he was deprived of a life with LEGO bricks, it's easy to imagine that he would have enjoyed a medium that combines art with engineering, as LEGO does. Da Vinci would have been especially intrigued by microscale building, where size constraints force your creations into sophisticated simplicity. The built-in minimalism of microscale construction lends itself to a beautiful, streamlined elegance reminiscent of early video game art. And just like early video game artists, who had to work with limited technology to convey complex images in creative ways, microscale builders work with certain restrictions to produce their unique aesthetic.

Even when LEGO building is reduced to its essence, it's astonishing how flexible it can be. For example, a LEGO micro city made on a 20×20-stud base can convincingly convey every real-world architectural style, as well as other styles seen only in fantasy and science fiction.

The following chapters will give you the tools to build your own micro city, from creating the base to adding the finishing touches that are the grace notes of every build. Don't be afraid to mix and match buildings from the examples that follow. After all, real cities feature buildings from many different eras, so you can combine several styles to suit your own tastes. Let this book be a starting point for your own fantastic designs.

BUYING BRICKS

Every brick used in this book came from an official LEGO set, a Pick a Brick wall at a LEGO store, or BrickLink. BrickLink is a website (*https://bricklink.com/*) where thousands of people around the world sell their bricks. You can search for bricks by entering the part number that accompanies the LEGO elements in the building instructions. You can also narrow your search to display BrickLink stores within your own country for faster and less expensive shipping. It's an amazing brick resource that would be hard to live without.

USING THE BRICKS YOU HAVE

Sometimes the best LEGO bricks are the ones you already have. The instructions in this book all feature build variations, and you're encouraged to add customizations of your own. It's seldom the case that only one specific brick will do. For example, you can easily replace a 2×8 brick with four 2×2 bricks. You can be even more flexible when choosing bricks for building ornamentation, since you can let your preferences guide your decisions.

Being restricted to the bricks you already have can open up new stylistic possibilities, as more limitations require more innovative thinking. This kind of creative mindset lets you embrace the constraints of using rare colors that are available only in limited shapes. Soon, you might even come to enjoy the challenges of building with just three or four piece types, which is much like solving a puzzle. It's been said that children don't play because it's easy; they play because it's hard. That's what microscale building is all about—serious play.

Now it's time to build your own LEGO micro city!

ACKNOWLEDGMENTS

Thanks to the worldwide LEGO community for providing continuous building inspiration while simultaneously being the nicest people on the internet. A special thanks to the Brothers Brick (*https://www.brothers-brick.com/*), the world's best LEGO blog, for honoring my LEGO micro city models as its 2017 LEGO Creation of the Year. It's been a pleasure to work with Annie Choi, Serena Yang, and Tyler Ortman, along with the other staff at No Starch Press, who are dedicated to producing such high-quality and imaginative LEGO books.

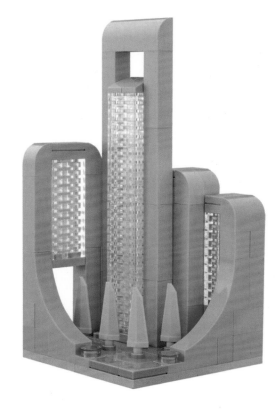

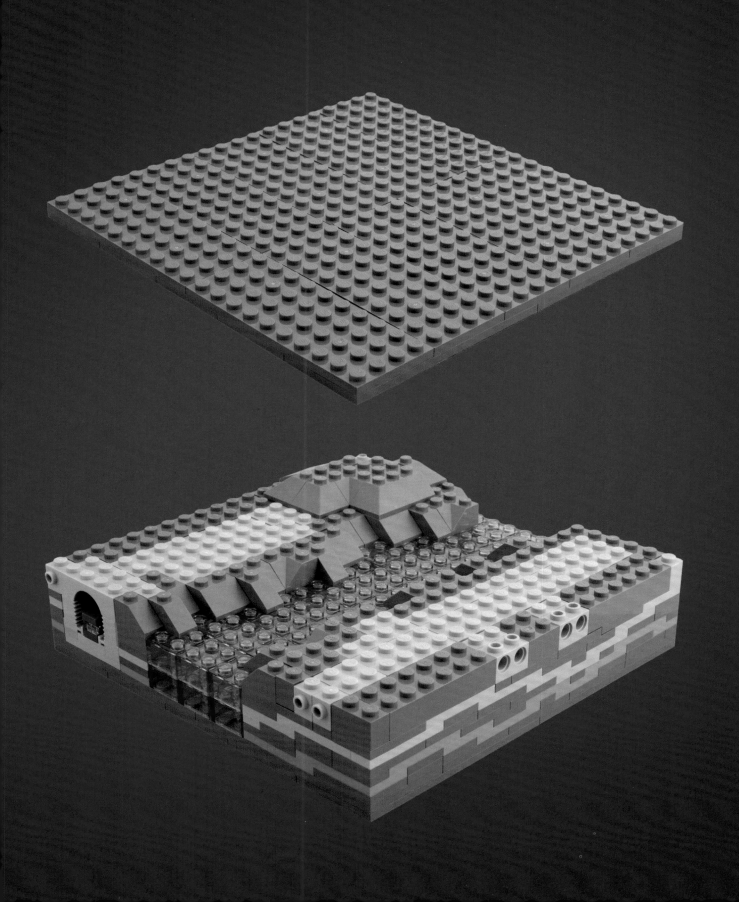

BASE CAMP

Your city's base is the bedrock upon which your buildings will rest. In LEGO, as in life, a solid foundation is the key to building anything of lasting value. Bases may seem like humble structures, but they're worth fussing over.

In this chapter, you'll build a micro city base that is both functional and beautiful. The LEGO micro cities you'll find in this book appear to have been carved out of the ground with a square cookie cutter. This results in a dynamic diorama that reveals some of the city's underground secrets.

The secret to building a great micro city is to think of it as a work of art. Every part of your city is important, and every brick should be considered with care. As your city grows, so does its story. A beguiling base is only the beginning.

PLATE STACK

The micro cities in this book are all made on a 20×20-stud base, which is big enough to support an array of microscale structures but small enough to ensure a microscale perspective.

20×20 VISION

As of this writing, the LEGO Group doesn't make a 20×20-stud base, but you can easily make your own. Simply gather your plates and form two flat 20×20-stud squares. The plate size doesn't matter as long as the end result leaves you with two 20×20 squares. After assembling the squares, stack one on top of the other, making sure that the top plates overlap the seams of the bottom plates. This binds the two layers of plates together.

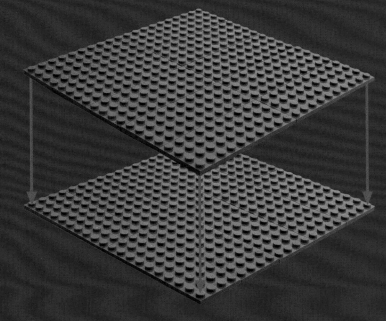

The example on the right displays two 20×20-stud squares made exclusively with 4×10 plates. Notice how the top square is rotated one quarter-turn so that the top plates join the bottom plates together into a solid base.

Because this 20×20-stud-plate stack will be your city's foundation, grey or earth-tone colors are a realistic choice—that is, if your city is on Earth.

RIVER

A river is an easy-to-build feature you can add to your micro city. Many of the world's great cities have a river running though them, so why not yours?

SHADES OF BLUE

Use either transparent blue or solid blue bricks to re-create flowing water.

Blue

Trans-Dark Blue

Medium Blue

Trans-Medium Blue

Medium Azure

Trans-Light Blue

Dark Azure

Brick availability is a key factor in choosing the shade of blue you'll use. The traditional blue color is found in all of the standard brick and plate sizes while transparent medium blue is rare and comes in limited sizes. To simulate calmer water, use tiles instead of bricks or plates.

3069

Note that only the visible areas of your river need to be the same color. If you don't have enough bricks of a certain color, you can use different-colored bricks to support your river from below, but keep in mind that the color will show through transparent bricks. Grey or earth-tone bricks are the safest options for placing under the river.

SUBWAY

A subway provides underground interest to your city, hinting at a vast network of tunnels beneath the streets.

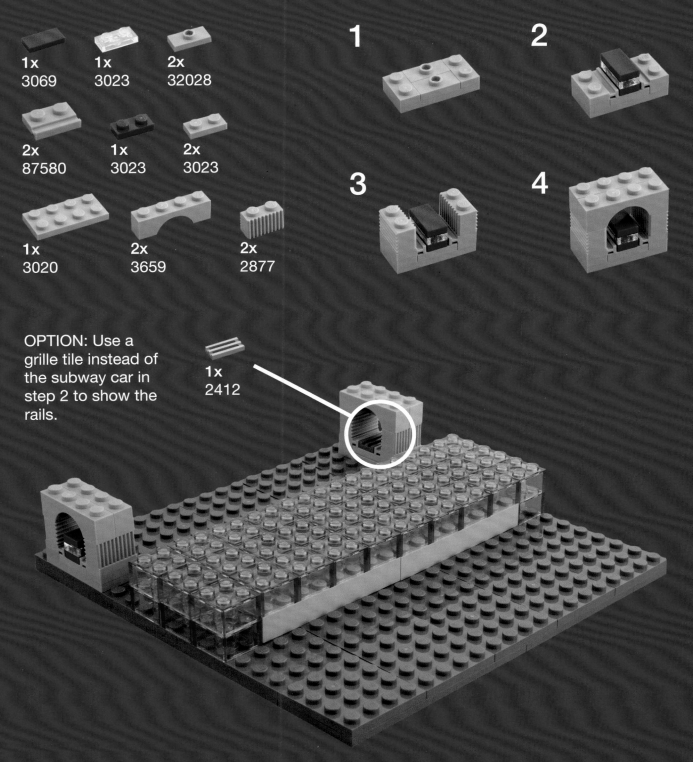

1x 3069

1x 3023

2x 32028

2x 87580

1x 3023

2x 3023

1x 3020

2x 3659

2x 2877

1

2

3

4

OPTION: Use a grille tile instead of the subway car in step 2 to show the rails.

1x 2412

GEOLOGY

You can use one solid color to represent the ground beneath your city, but consider adding geological stratification for realism and to showcase compelling brick artistry.

EARTH TONES

As their name implies, earth-tone bricks are the perfect choice to represent the layers of earth your city is built upon.

Dark Grey

Dark Tan

Light Grey

Dark Orange

Sand Green

Tan

Olive Green

Reddish Brown

Geologic stratification looks more elegant in thin layers, so use plates rather than bricks for this effect.

Building stratification layers is a freeform technique, so feel free to make it your own! Here is a sample cross-section to get you started.

We use 2×2, 2×3, and 2×4 plates on the base's sides, but you could use 1×2, 1×3, and 1×4 plates instead.

MAKING YOUR BASE LEVEL

You can fill hollow pockets in the base to provide a level surface for your city.

ANY BRICK THAT FITS

None of the fill bricks will be visible in your finished city, so you can use bricks of any color and size that fit the hollow spaces in your base. The only exception is the row of bricks next to any transparent bricks.

THE ONE EXCEPTION

If your river is made of transparent blue bricks, be sure to use grey or earth-tone fill bricks next to the transparent bricks. If you use a bright color like red, it will show through the transparent blue and make your water look purple!

Here, we use two levels of 2×4 bricks to fill the base, but you can use any brick that fits.

Use grey to keep your rivers blue!

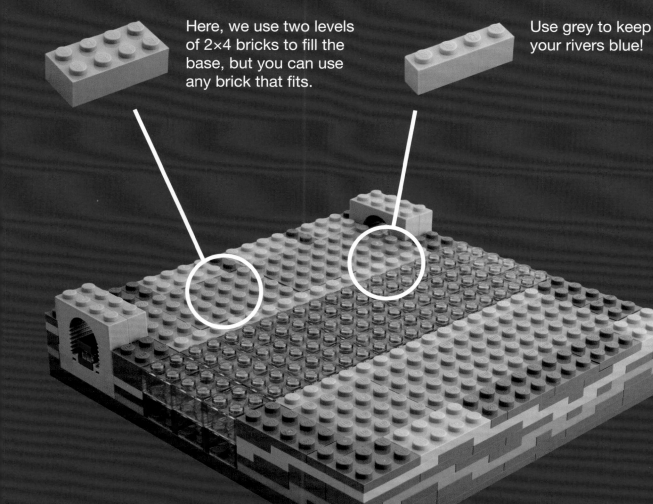

FINISHED BASE 1

This is an example of a good base with a bounty of open studs that are ready for your infrastructure, landscaping, buildings, and other architectural designs.

RIVERBANK

This base features a riverbank contained by a reinforced concrete shore. The angled 2×2 brick, known as a modified facet 2×2 (part #87620), lets you shape the river's meandering form.

VISIBLE SIDES

Build up the bedrock on the base's sides to match the riverbank's height. The color should match your dominant bedrock color, but brick size is unimportant as long as it fits.

PIPES

Re-create underground infra-structure, such as sewers, water pipes, and conduits, using Technic bricks or bricks with a side-facing stud, which you'll learn more about when we explore *studs not on top (SNOT)* techniques in "Gearhead Trading Co." on page 25.

87620

11211 + 98138

2877

Use any brick that fits.

3200

87087

FILL

Fill in the hollow pockets with any brick that fits, keeping the surface level with the riverbank and sides.

FINISHED BASE 2

This version features a natural rocky riverbank instead of a concrete one. There is also a hill to add interest to the terrain. The base's sides remain the same as in Base 1.

USING SLOPE BRICKS

Slope bricks are ideal for simulating rocky shores. Stagger the slope bricks along the river to create a rugged shoreline. To make a hill, first fill in the hollow pockets between the finished riverbank and the base's sides with any brick that fits. The land area of your base should be level at this point. Then, place a group of slopes on top of the land, with every slope touching at least one other to create a mound.

4286 3046 3045 3039 3040

Slope bricks can be one brick to five bricks high. This base uses only slopes that are one brick high for ease of leveling.

FILL

As before, fill in the hollow pockets with any brick that will fit, as long as they're level with the riverbank and sides.

SMALLER BASE OPTIONS

While a thick 20×20-stud base complete with subways and detailed geology is impressive, you can still build a stunning micro city on a smaller and simpler base.

TWO PLATES TALL

This base rests on a tan 16×16 plate (part #91405), which we top with tan and transparent light blue plates to represent water and sand, respectively.

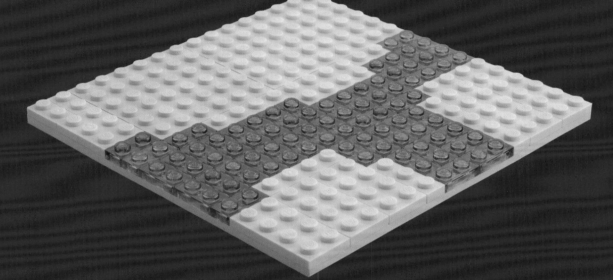

NARROW FOCUS

This base uses a grey 8×16 plate (part #92438), which we top with grey and transparent light blue plates. We built the riverbank on top of the plates using techniques from Base 1. Despite its size, this small base has room for at least three microscale buildings.

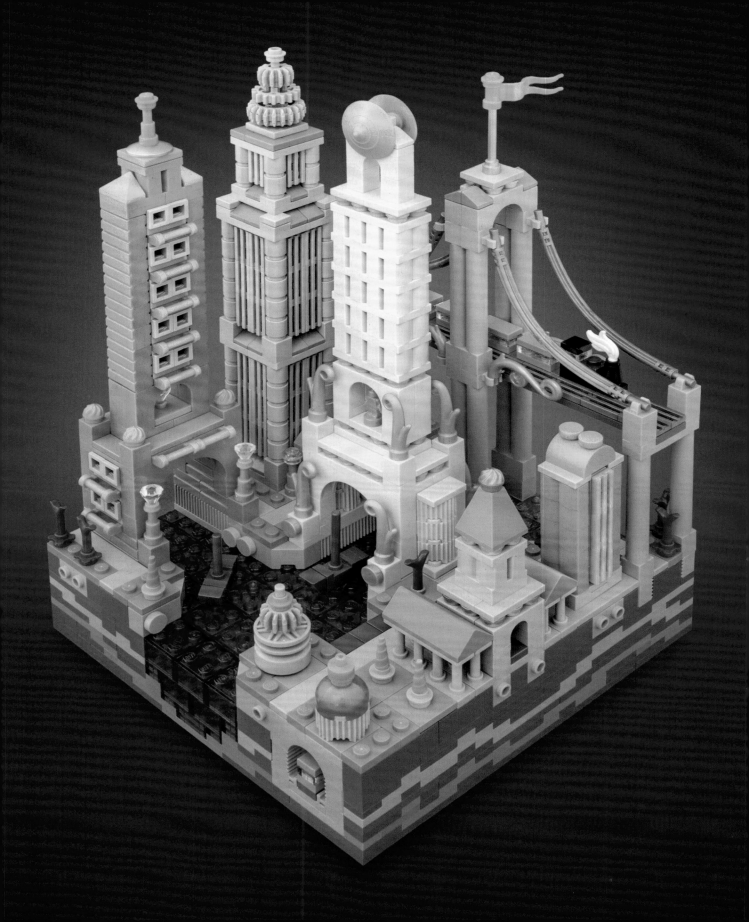

GILDED CITY

The world's first cities rose up in four different parts of the world: Mesopotamia, ancient Egypt, the Indus Valley, and China's Yellow River valley. These places all have one geographic feature in common: a life-giving river runs through each one. These rivers provided the dual gift of fresh water and fertile soil, the ingredients needed for agriculture, which in turn allowed people to settle in one place rather than spend their lives chasing migratory animals. Once settled, they began to build permanent shelters, which multiplied into cities.

Today, you'll find thousands of riverside cities, many of which are major world capitals. Central Europe's Danube flows through four national capitals itself. It's almost as if rivers have the power to sprout cities on their banks.

A city's river is also indispensable to that city's soul. London without the Thames would be like tea without crumpets. New Orleans without the Mississippi would be like jambalaya without Cajun seasoning. Paris without the Seine would be like a baguette without butter.

This LEGO micro city sits at the confluence of two rivers, providing two different trade routes that have generated ostentatious wealth. The city's abundant cash flow gave rise to a flood of gilded buildings as wealthy merchants sought to outshine one another with ornamental one-upmanship.

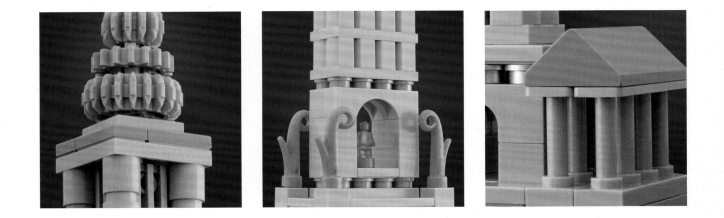

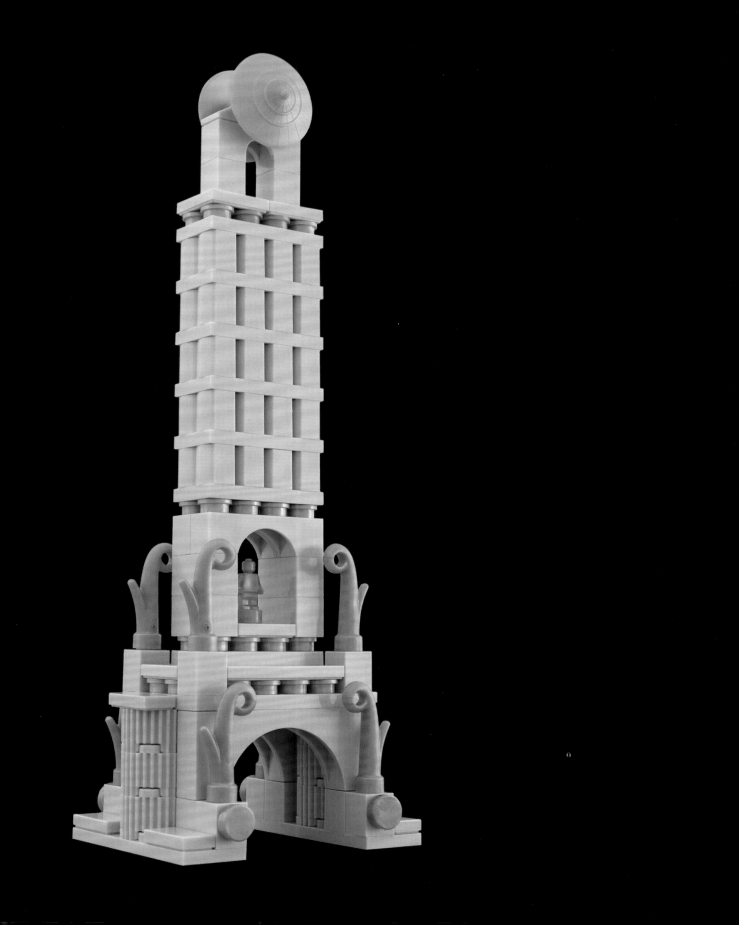

SUN GATE ESTATES

Sun Gate Estates was built by global shipping magnate Gimlet D. Goldenpaddle, who made a fortune with his Do Pay the Ferryman river transportation service. His opulent tastes and high self-regard are evident in the building's polished gold ornamentation and the statue of him that welcomes visitors to the city.

Place 1×2 "log" or palisade bricks side by side to make elegant vertical windows.

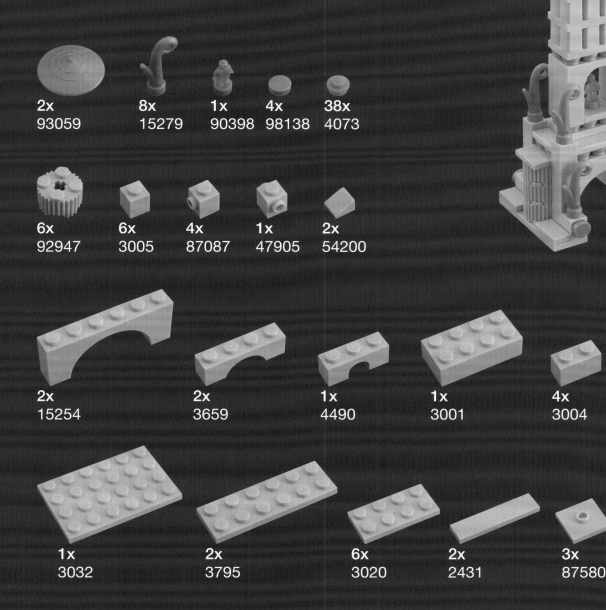

2x	8x	1x	4x	38x
93059	15279	90398	98138	4073

6x	6x	4x	1x	2x
92947	3005	87087	47905	54200

2x	2x	1x	1x	4x	20x
15254	3659	4490	3001	3004	30136

1x	2x	6x	2x	3x	8x
3032	3795	3020	2431	87580	3069

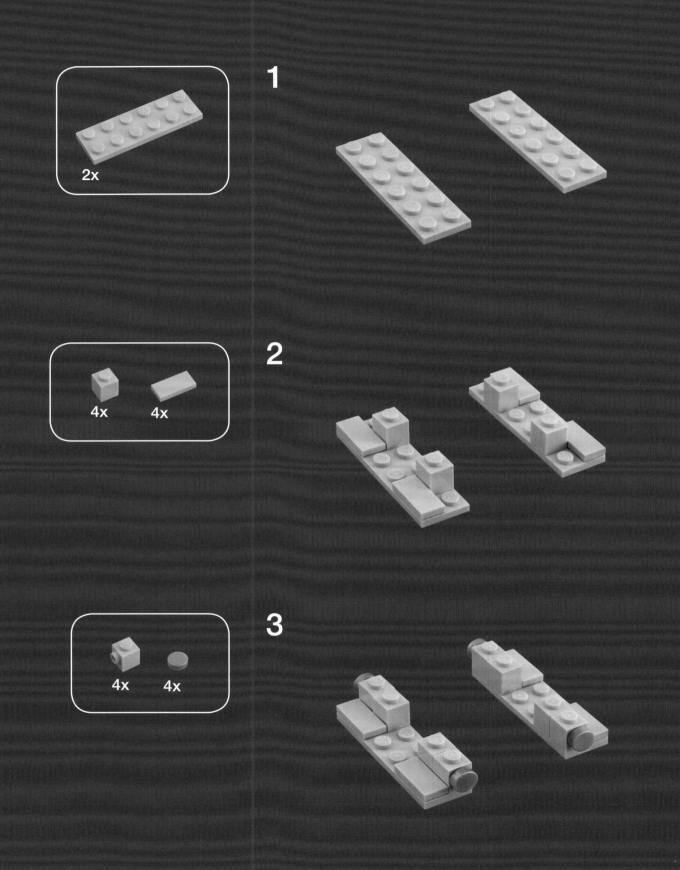

1

2x

2

4x　　4x

3

4x　　4x

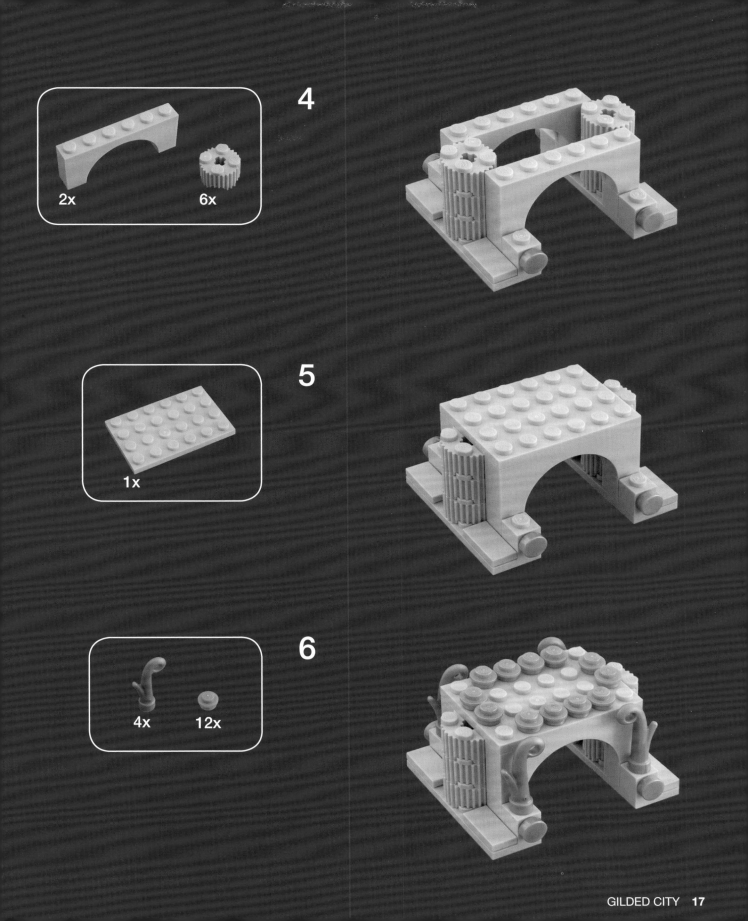

4

2x

6x

5

1x

6

4x

12x

7

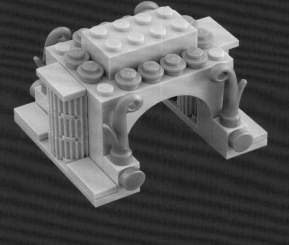

8

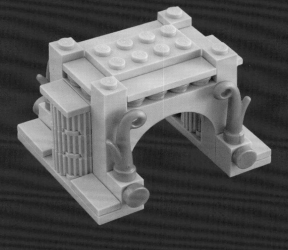

9

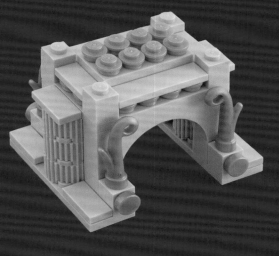

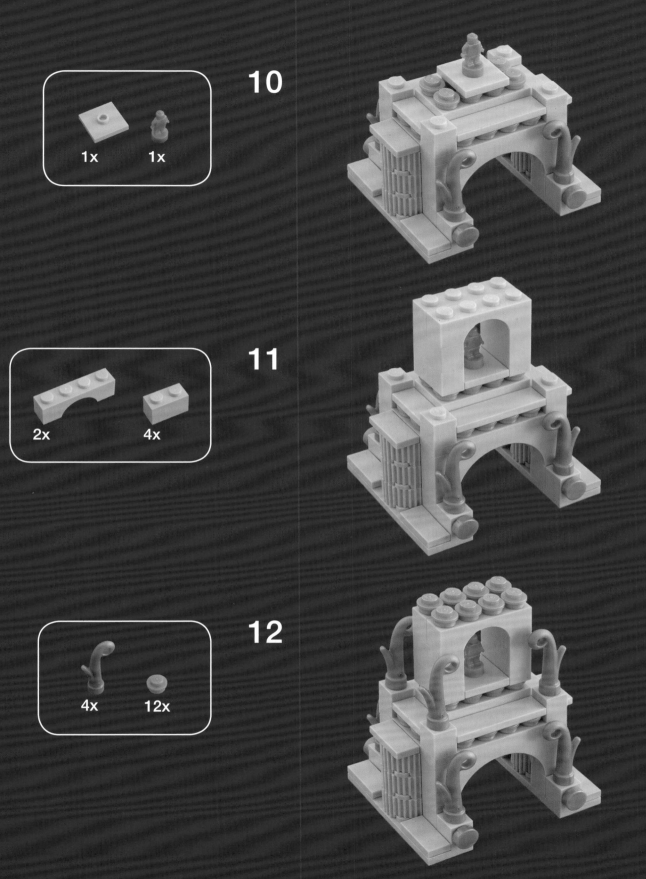

10

1x 1x

11

2x 4x

12

4x 12x

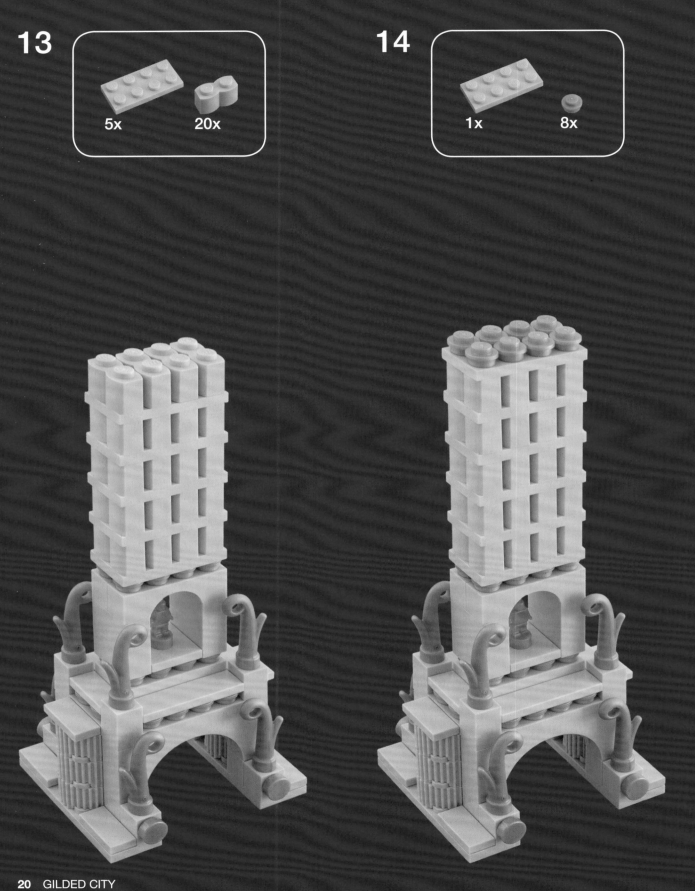

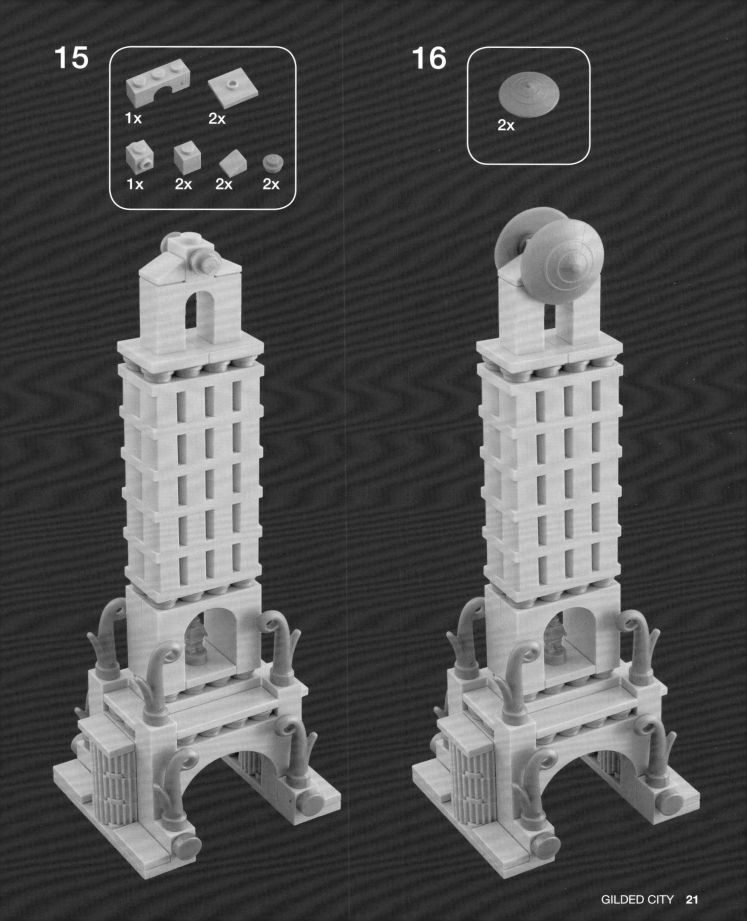

MAKE IT YOUR OWN

Sun Gate Estates was inspired by a 1957 Chevrolet Bel Air with all of the options. To customize this build to your taste, try swapping out the decorative pieces with the following parts. Note that you can also build the tower itself with alternate bricks.

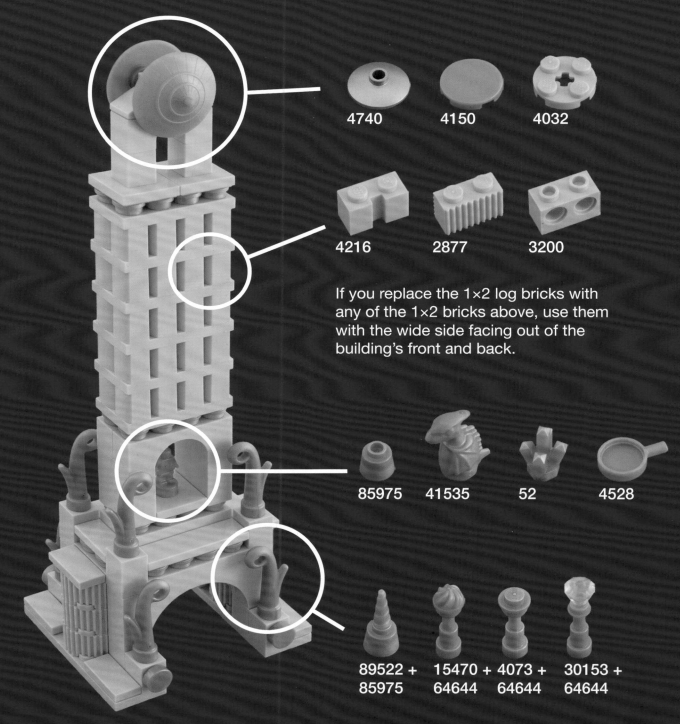

4740

4150

4032

4216

2877

3200

If you replace the 1×2 log bricks with any of the 1×2 bricks above, use them with the wide side facing out of the building's front and back.

85975

41535

52

4528

89522 +
85975

15470 +
64644

4073 +
64644

30153 +
64644

ALL THAT GLITTERS IS NOT GOLD

If you don't have any specialty pearl gold bricks in your collection, replace the gold ornamentation with a few tan-colored round plates for a more pared-down look.

BUILD LIKE IT'S 1982

Don't worry if you don't own any fancy-colored bricks and haven't bought any new parts since Yoda first lit up the big screen. You can build a retro-cool version like this using only white bricks made before 1982.

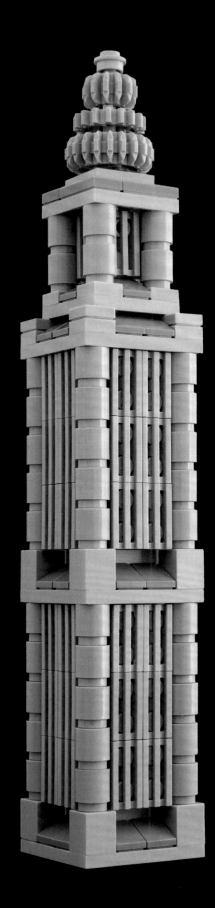

GEARHEAD TRADING CO.

The Gearhead Trading Company headquarters has a sprocket-based crown, which spins using leftover steam from the company's many espresso machines.

You'll use the SNOT technique to build these microscale windows. Despite the unfortunate acronym, SNOT bricks are useful because they have one or more studs on their sides, which allow you to build out horizontally. In this building, we use a SNOT brick to place 1×2 grille tiles on top of 2×6 plates, which we then attach to the sides of the building.

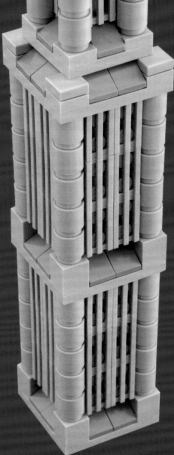

1x
32269

1x
94925

1x
32270

40x
3062b

1x
30374

52x
2412

4x
3069

24x
54200

1x
85861

10x
3004

10x
3005

1x
4733

8x
87087

5x
3024

4x
3070

3x
3031

2x
11212

8x
3795

1x
3022

2x
87580

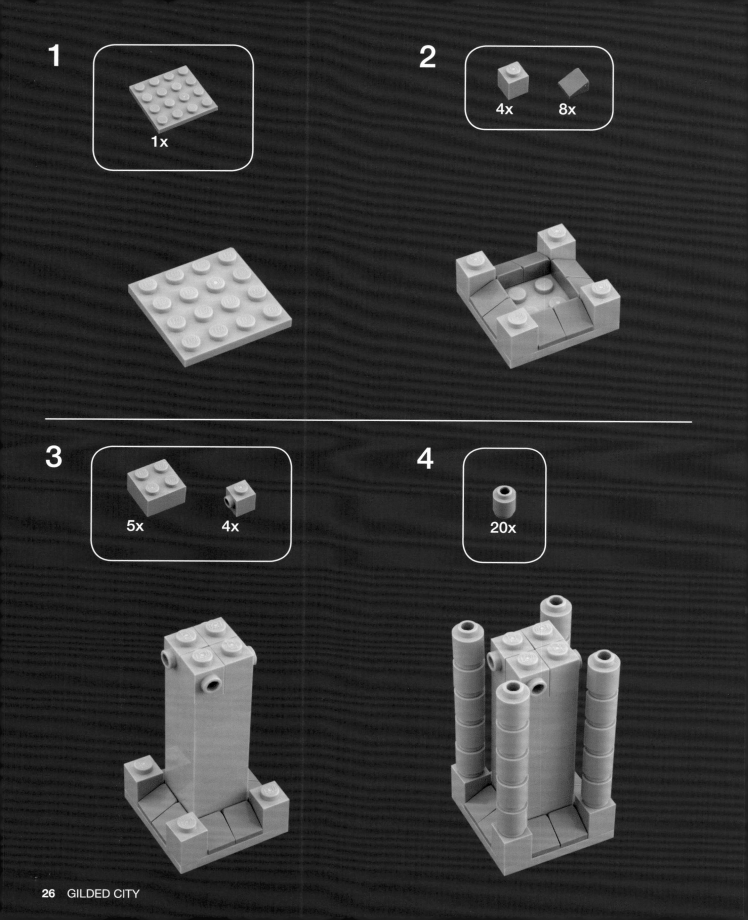

5

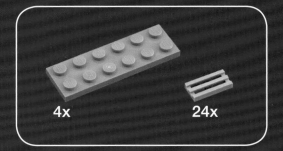

4x 24x

Attach the 1×2 grille tiles to the 2×6 plates, and then attach the 2×6 plates to the horizontal stud on each side of the building's core. This results in a surprisingly strong connection that won't loosen easily.

Here, we use dark tan plates to add a subtle color variation, but grey or black plates would be perfect substitutes.

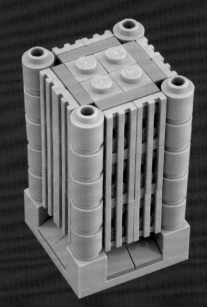

2x

6

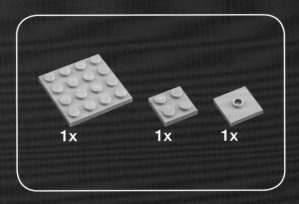

1x 1x 1x

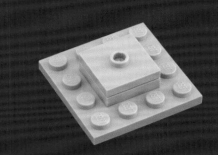

7

8x 4x 4x

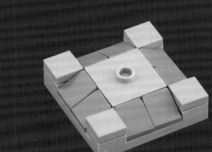

8

 8x

1x 5x

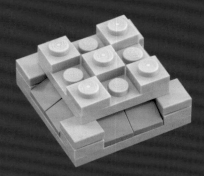

9

1x 1x 4x

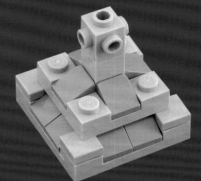

10

4x

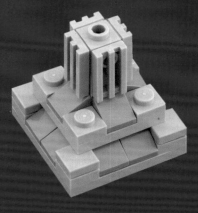

11

8x

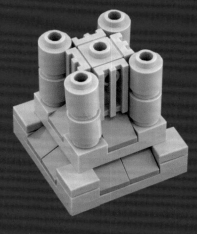

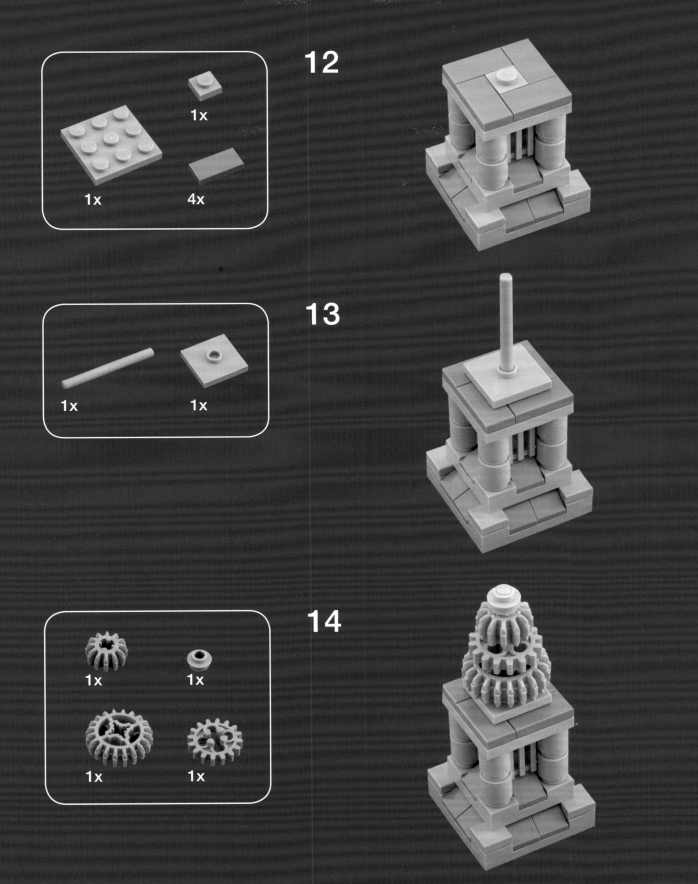

12

1x

1x 4x

13

1x 1x

14

1x 1x

1x 1x

We'll use two of the modules from step 5 in this build, but you can make your skyscraper taller by adding more modules.

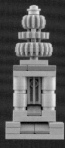

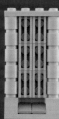

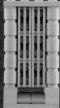

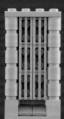

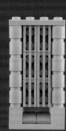

15

Here's where everything comes together. Stack the three modules and behold the sight of your own skyscraper coming together.

It's a long way down!

MAKE IT YOUR OWN

**4716 +
3957**

**64644 +
3062**

**553 +
92947**

3942

3688

To replace the
SNOT windows with
a studs-up build,
remove the existing
2×2 brick structure
and the 1×1 slope
tiles. Then stack
six 1×2 log bricks
or 1×2 bricks with
grille where the slope
tiles used to be.

30136

2877

Stack plain old 1×1
bricks to replace the
1×1 round bricks
and make angular
columns instead. To
add even more tex-
ture, try 1×1 round
plates. If you don't
have enough bricks
to stack, simply use
1×1×6 solid pillars.

43888

4073

3005

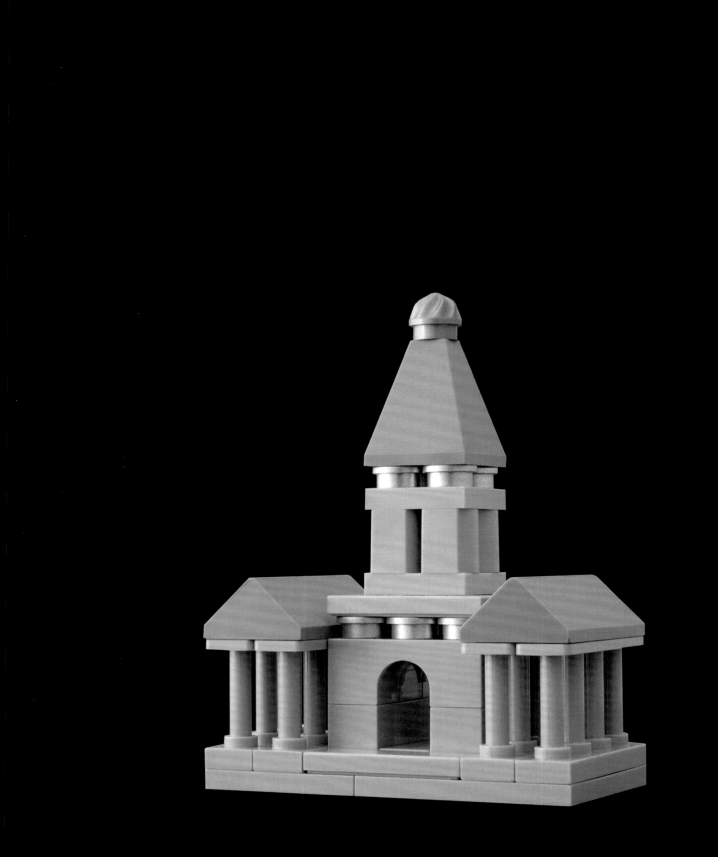

CITY HALL

Will this municipal building project be on time and under budget? It's your choice, Mayor. Sand green is a rare color in the LEGO palette. In fact, it's one of the three most expensive colors on BrickLink. You can avoid hiking taxes by using grey instead.

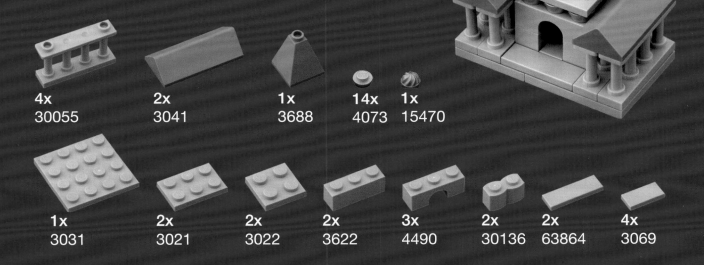

4x	2x	1x	14x	1x
30055	3041	3688	4073	15470

1x	2x	2x	2x	3x	2x	2x	4x
3031	3021	3022	3622	4490	30136	63864	3069

1

1x 2x

2

2x

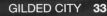

3

2x

3x

4

9x

5

4x

1x

6

2x

2x

4x

7

1x 1x

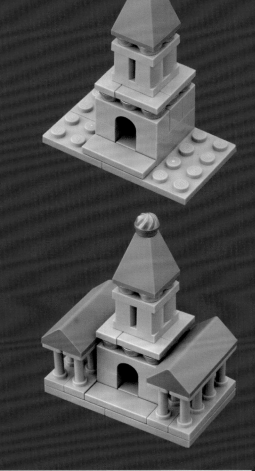

8

4x

2x

MAKE IT YOUR OWN

You can use light grey, dark grey, or black slope bricks in place of sand green ones.

Replace the 1×4 fence bricks with thicker columns made of 1×1 round bricks for a more substantial look.

90398 4589

3044 3040

3062b

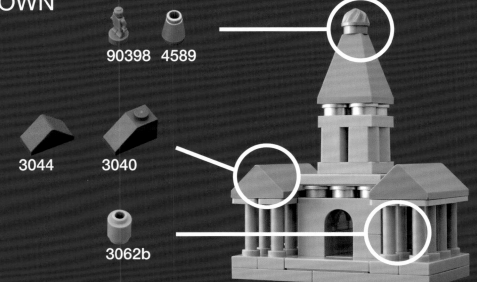

UPPER BRICK SIDE

The true sign of a civilized city is not its buildings, but rather a place where no buildings stand: the public park. The best cities always have a spot where their citizens can retreat to a pocket of the natural world and relax under the open skies. Those who have the foresight to set aside valuable city land for public parks give a gift to every generation that follows.

Adding a public park to your LEGO micro city is as easy as laying down a few green plates to represent grass. The park will provide some breathing room for your constructions in the same way that negative space is important to a painting's composition. Parks also provide refreshing color contrast against neutral-colored buildings.

One side effect of public parks is that they tend to drive up the real estate values of nearby properties, sometimes to stratospheric heights. This micro city is inspired by the opulent apartment buildings that surround New York City's Central Park like a baroque castle wall.

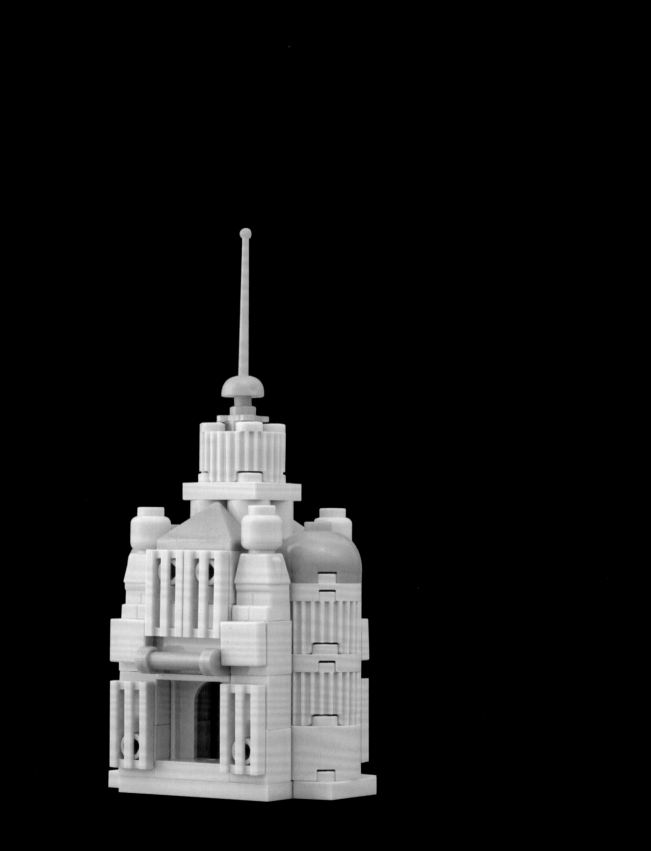

BRICK TEMPLE

The Brick Temple protects the sacred paperwork for patent no. 3,005,282, which was filed for the first LEGO brick!

This model uses specialty bricks to mimic fine carving, but at the heart of its construction, you'll find that original 2×4 brick.

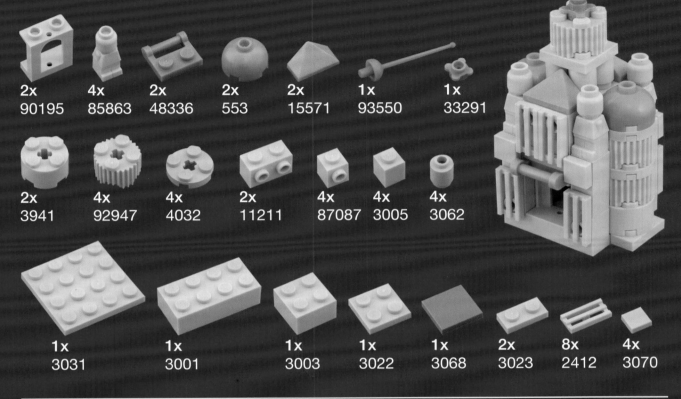

| 2x 90195 | 4x 85863 | 2x 48336 | 2x 553 | 2x 15571 | 1x 93550 | 1x 33291 |

| 2x 3941 | 4x 92947 | 4x 4032 | 2x 11211 | 4x 87087 | 4x 3005 | 4x 3062 |

| 1x 3031 | 1x 3001 | 1x 3003 | 1x 3022 | 1x 3068 | 2x 3023 | 8x 2412 | 4x 3070 |

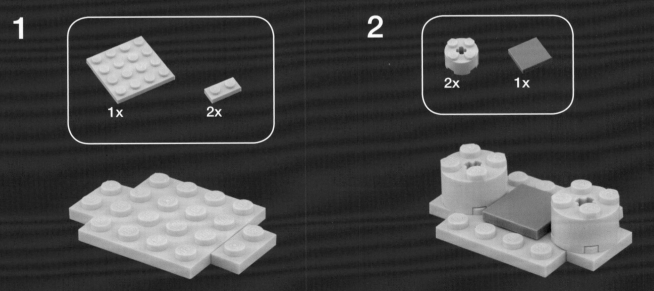

1

1x 2x

2

2x 1x

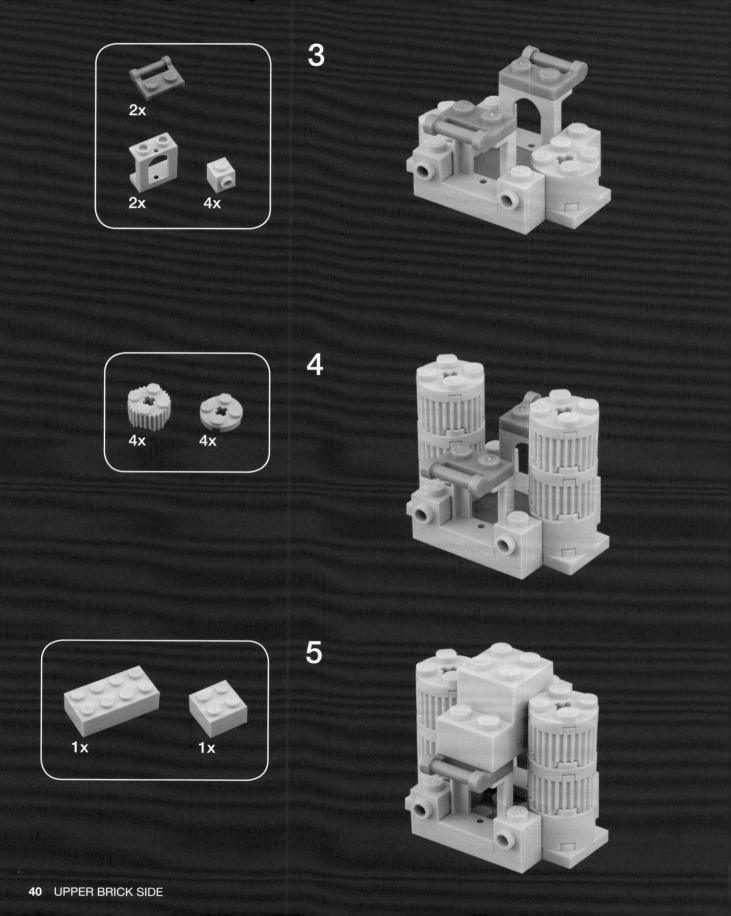

3

2x

2x 4x

4

4x 4x

5

1x 1x

6

Attach the grille tiles and 1×1 tiles to the SNOT bricks as shown. The Brick Temple's front and back are identical, as are its sides.

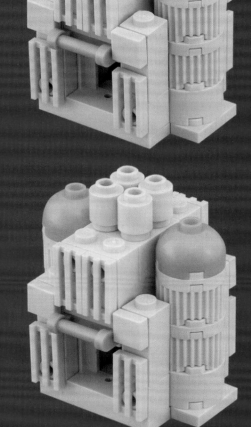

7

8

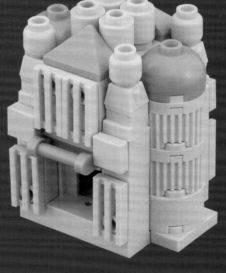

MAKE IT YOUR OWN

You can use minifigure accessories, such as fencing sabers and ski poles, to re-create intricate temple spires, but a plain bar works just as well.

If you don't have the microfigures used here as statues, try regular 1×1 bricks topped with clips or round tiles instead.

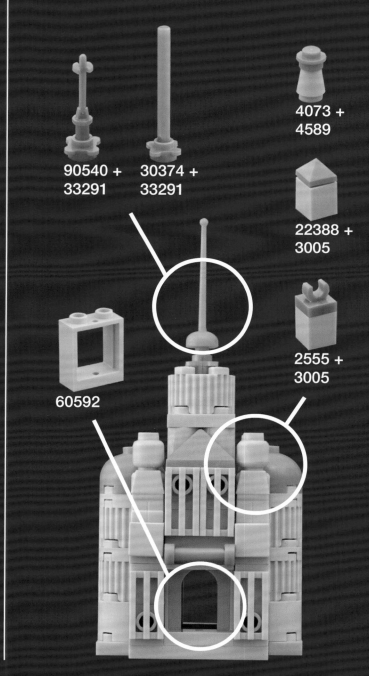

90540 +
33291

30374 +
33291

4073 +
4589

22388 +
3005

2555 +
3005

60592

BUILDING BIG IN MICROSCALE

Just because you're building in microscale doesn't mean you can't make something awe-inspiring. Apply the same techniques used for the Brick Temple to build this Mega Brick Temple. Just add more bricks as you see fit.

If you're limiting the city to a 20×20 stud base, remember not to exceed 20 studs in length with this build!

The Mega Brick Temple uses just three extra parts that aren't in the original Brick Temple. Can you find them?

Hint: They are stacked on top of one another.

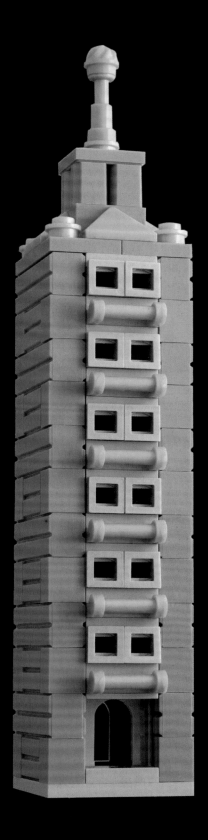

THE FALCON'S ROOST

The Falcon's Roost has a purposely built nesting niche for red-tailed hawks in its cupola. The hawks keep the rats away, but they do attract birders with big binoculars.

Stacking headlight bricks creates convincing square window frames for microscale buildings.

2x 90195	12x 48336	1x 64644	4x 15571	1x 15470	4x 4073
1x 3003	36x 98283	4x 30136	24x 3005	24x 4070	22x 3023
1x 3031	1x 3020	4x 3022	1x 87580		

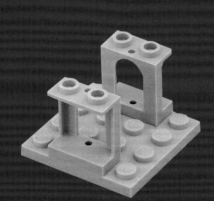

1

1x 2x

2

18x 12x

Staggering the
bricks helps
strengthen
the wall.

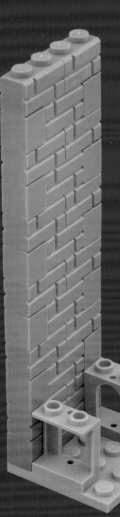

3

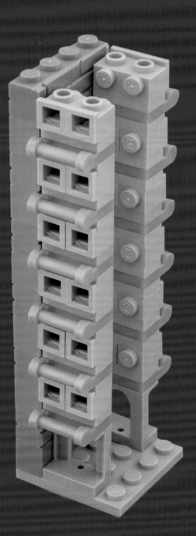

22x

12x 24x

Make two stacks and
then attach each one to
the top of a doorframe
to create the windows.

4

18x 12x

5

1x

6

4x

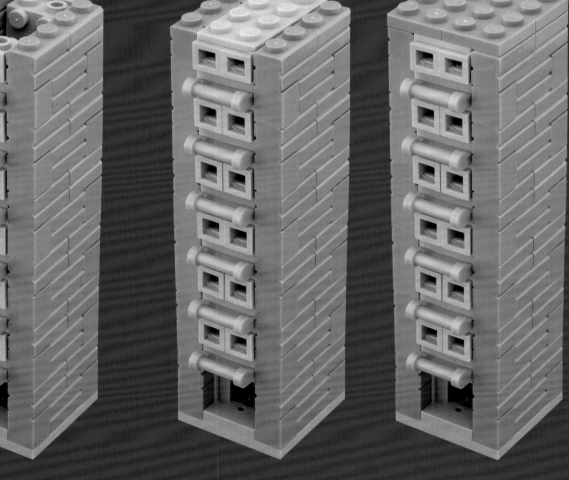

7

4x 4x

8

1x 1x

1x 1x 1x

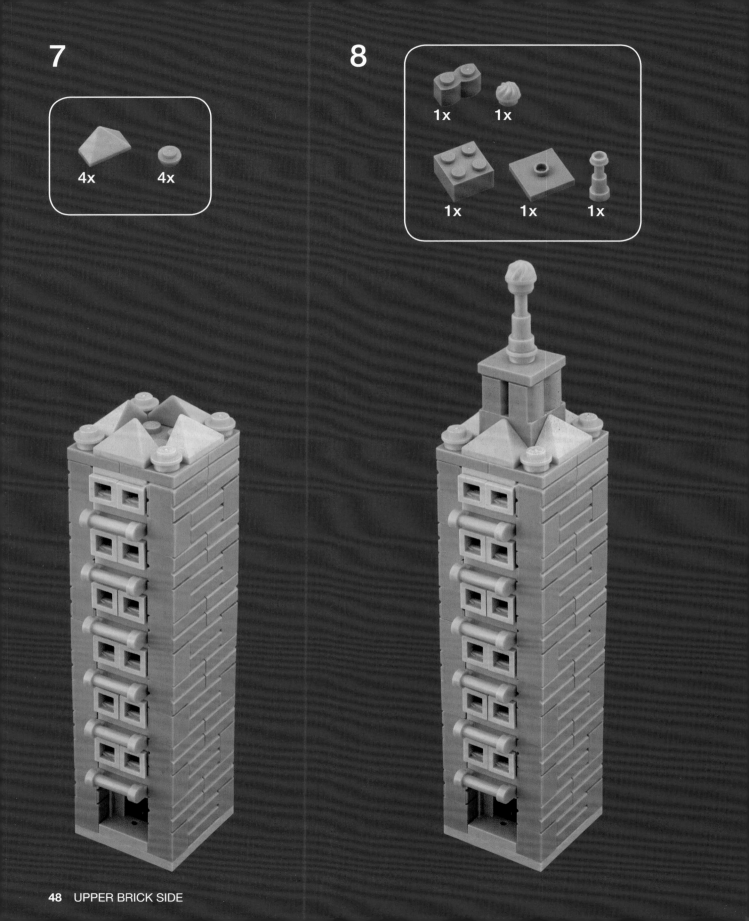

MAKE IT YOUR OWN

You can customize the window stacks by using different modified plates between the headlight bricks. Two great choices are the 1×2 plate with door rail (part #32028) and the 1×2 plate with a free-ended handle (part #2540).

32028

The 1×2 plate with door rail provides a simple windowsill for an austere building.

2540

The 1×2 plate with a free-ended handle evokes carved stonework for an expensive or old-fashioned building.

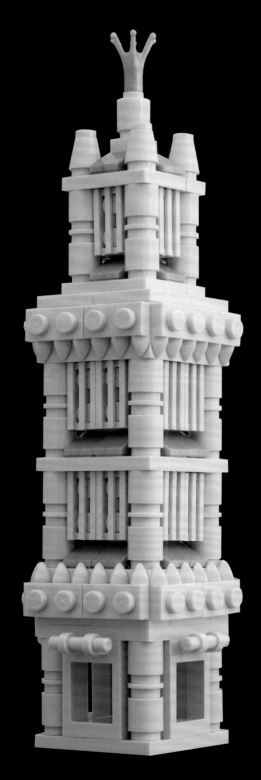

CROWNING GLORY

The Crowning Glory was hand-carved by renowned sculptors from around the world who were specially selected for the job. The sculptors had a dust-up about stylistic differences, but they eventually chiseled out an agreement to stop throwing hammers at each other.

Set on a mere 4×4-stud footprint, this building stretches the limits of microscale detailing.

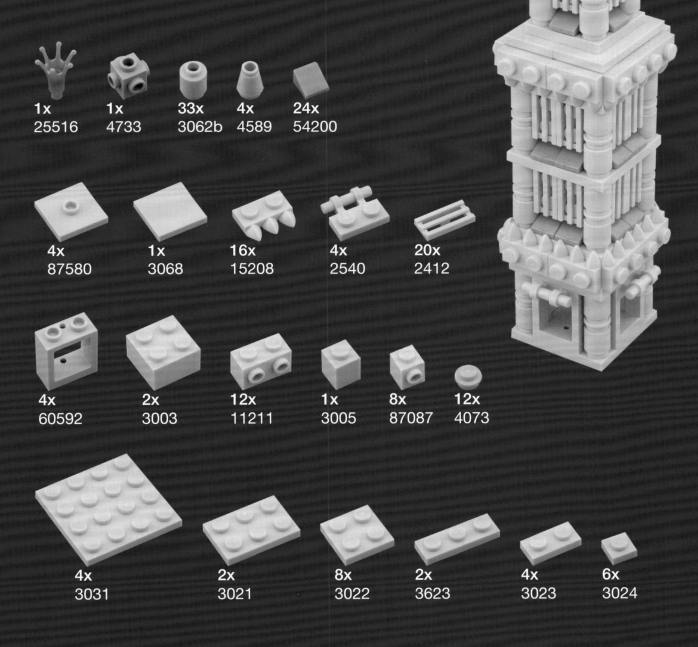

1x
25516

1x
4733

33x
3062b

4x
4589

24x
54200

4x
87580

1x
3068

16x
15208

4x
2540

20x
2412

4x
60592

2x
3003

12x
11211

1x
3005

8x
87087

12x
4073

4x
3031

2x
3021

8x
3022

2x
3623

4x
3023

6x
3024

1

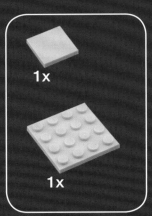

1x

1x

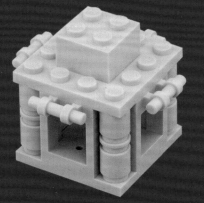

2

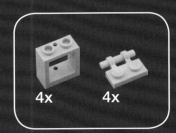

4x 4x

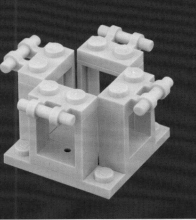

3

8x 4x

All sides should
be identical.

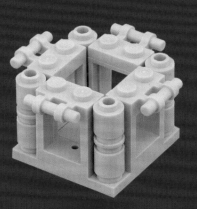

4

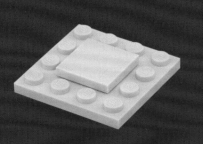

1x 1x

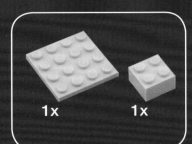

5

6x

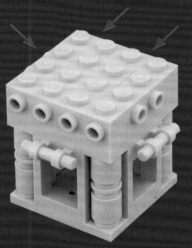

6

1x

1x

7

4x

All sides are
identical from
step 7 to step 10.

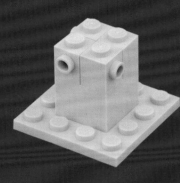

8

8x

9

4x 8x

Attach the 2×2 plates
to the SNOT bricks.

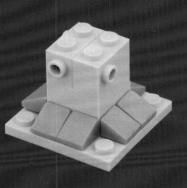

10

8x 4x

2x

11

1x

1x

12

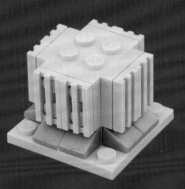

6x

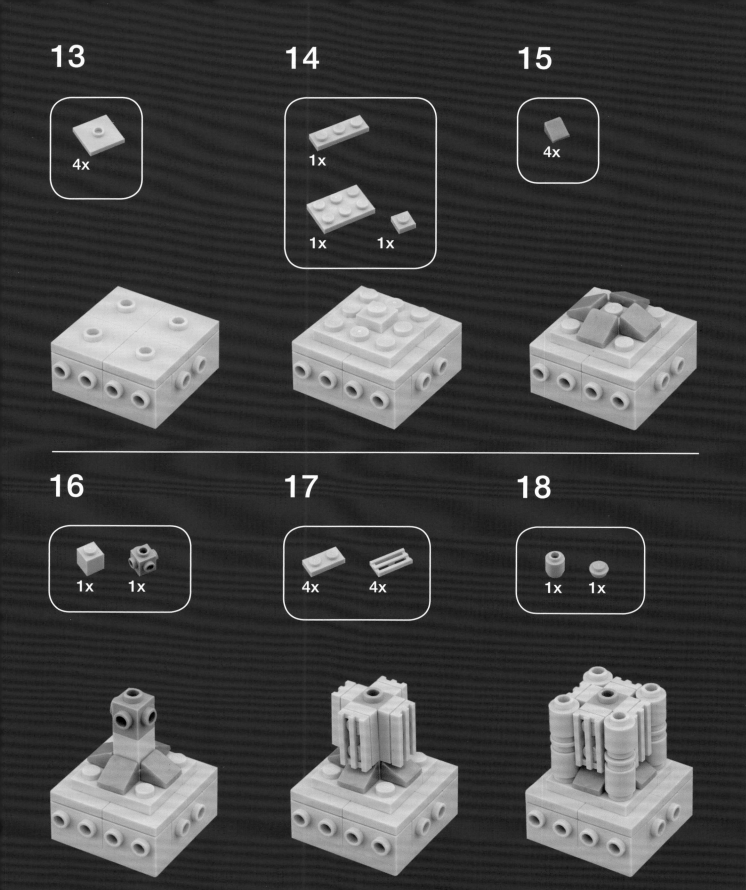

19

4x

1x

1x

20

1x 4x

1x 1x

21

Stack all the
modules
together
and admire
the glory of
your hand-
sculpted
creation.

MAKE IT YOUR OWN

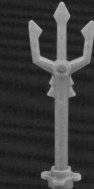

The Crowning Glory is designed to showcase the fine detailing you can re-create in microscale. Why not make an even more detailed version?

98138 + 64644 92289 + 33291

98138 + 3005 15470 + 3005 87087 + 98138

3710

3710 + 98318

2431

30413

You can replace the inline pairs of 1×2 plates with teeth on the sides with a 1×4 plate, tile, or panel. The 1×4 plate lets you attach more bricks sideways.

48336 90195

MAKE IT A DOUBLE

The Crowning Glory is like a chocolate truffle: sometimes you need more than one to satisfy your craving. Thanks to LEGO's precise engineering, it's easy to build two identical buildings if you have the parts.

You can also join the twin buildings with a charming bridge! Connect the two towers with a plate that provides a 4-stud span between buildings. Decorate the bridge to match the buildings.

You can replace the SNOT windows and the SNOT brick facing the bridge with a door.

90195 2540

Use this space to build a park, a road, or a building that is shorter than the bridge.

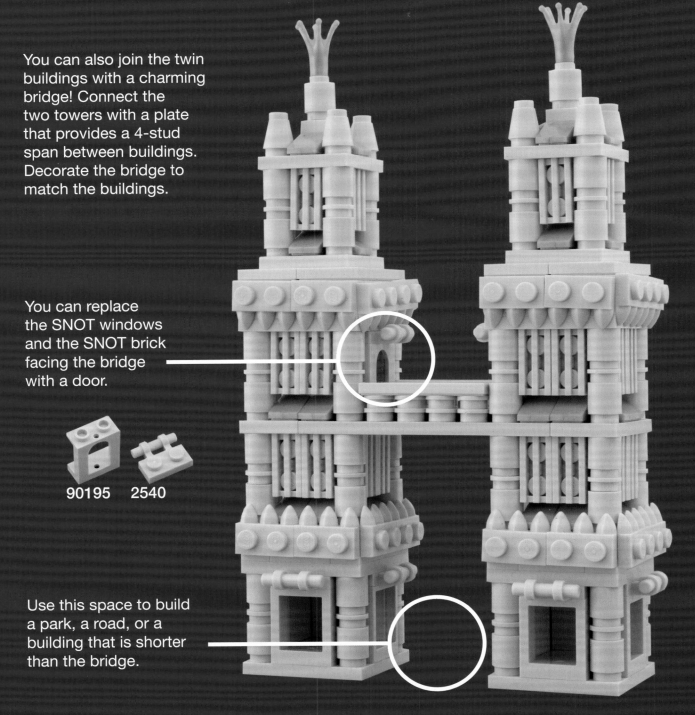

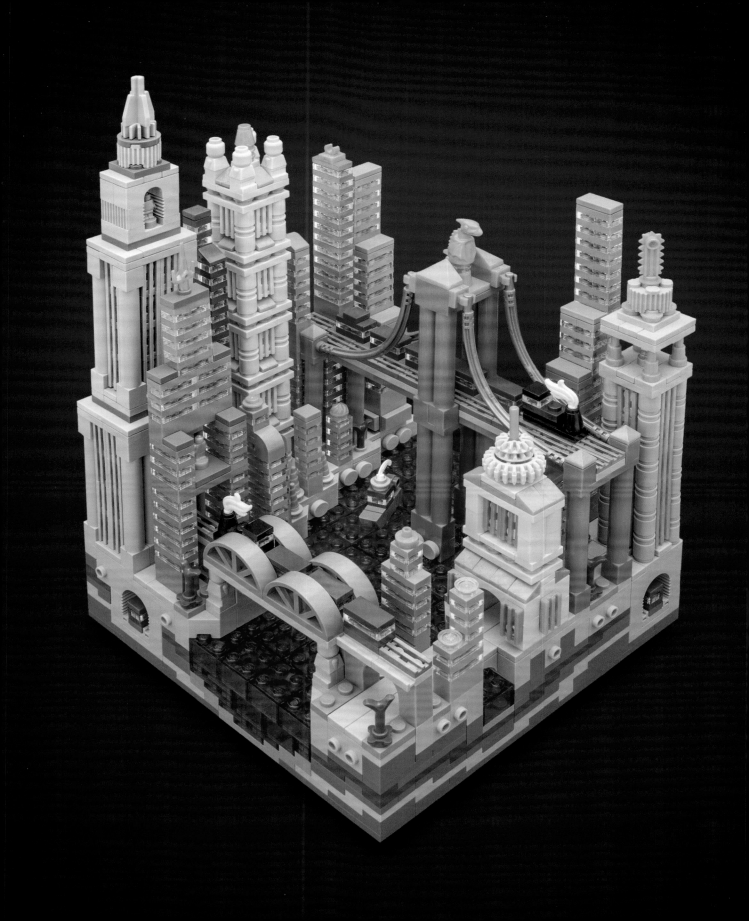

BRIDGE TOWN

Bridges are celebrated in a way that most other public works are not. In New York City, for example, the Brooklyn Bridge is a cherished landmark while the Lincoln Tunnel, which serves essentially the same purpose, is something you have to endure. Bridges transcend their practical function and cross into a realm of poetry and metaphor usually reserved for natural wonders.

In the same way, bridges can provide multiple levels of delight in a LEGO micro city. You can use them not only for practical purposes like providing passage over water and linking your cities together, but also to make an artistic statement. Your bridge design can be as individual as your fingerprint. You can build a simple plank bridge to cross a creek or construct a soaring wonder that becomes the centerpiece of your city's architecture. What will your bridge's story be?

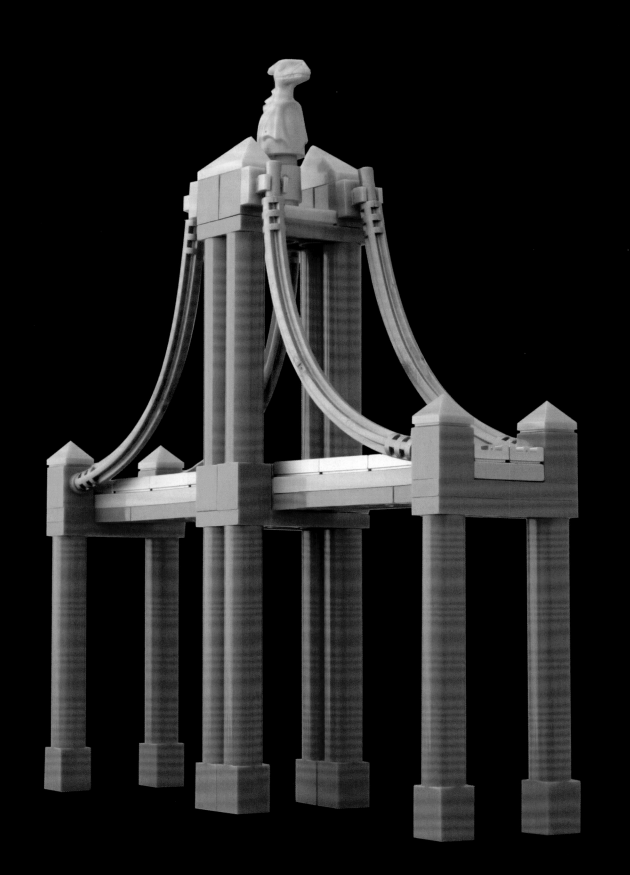

DRAGON CROSSING

The Dragon Crossing bridge stands at an ancient ford called Dragon's Path, named after a curving pile of half-submerged boulders resembling a dragon's back. According to local lore, the golden dragon on top of the bridge comes to life and breathes out the fog that shrouds this city on autumn mornings.

With just a handful of bricks, this iconic bridge adds so much character to your LEGO city. You can add plates or bricks to the bridge's foundation as necessary to adjust to the varying terrain of your city.

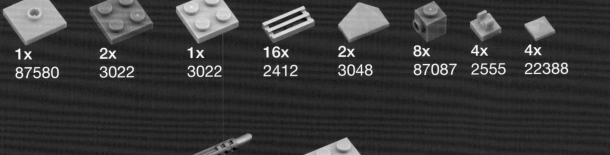

1x	1x	2x	1x	16x	2x	8x	4x	4x
41435	87580	3022	3022	2412	3048	87087	2555	22388

12x	4x	2x	5x	4x
43888	32200	3034	3020	3710

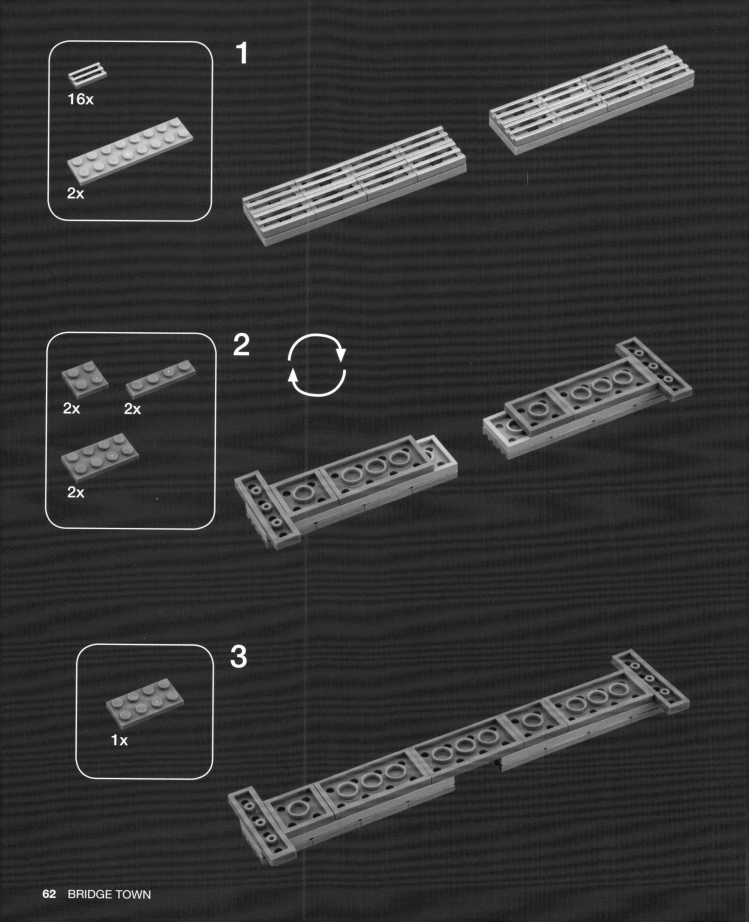

1

16x

2x

2

2x 2x

2x

3

1x

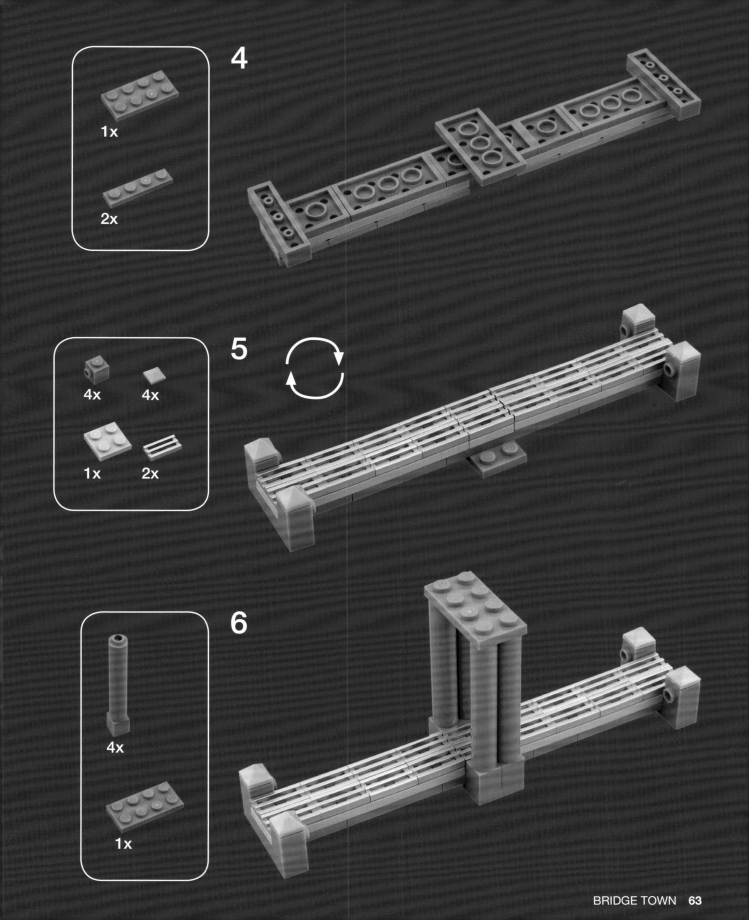

4

1x

2x

5

4x 4x

1x 2x

6

4x

1x

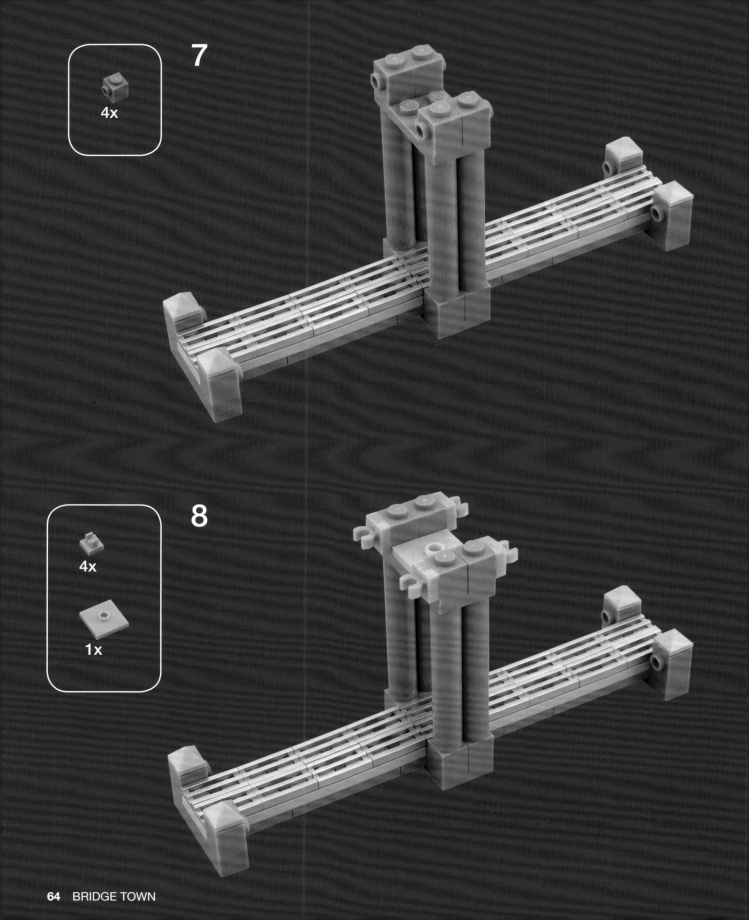

7

4x

8

4x

1x

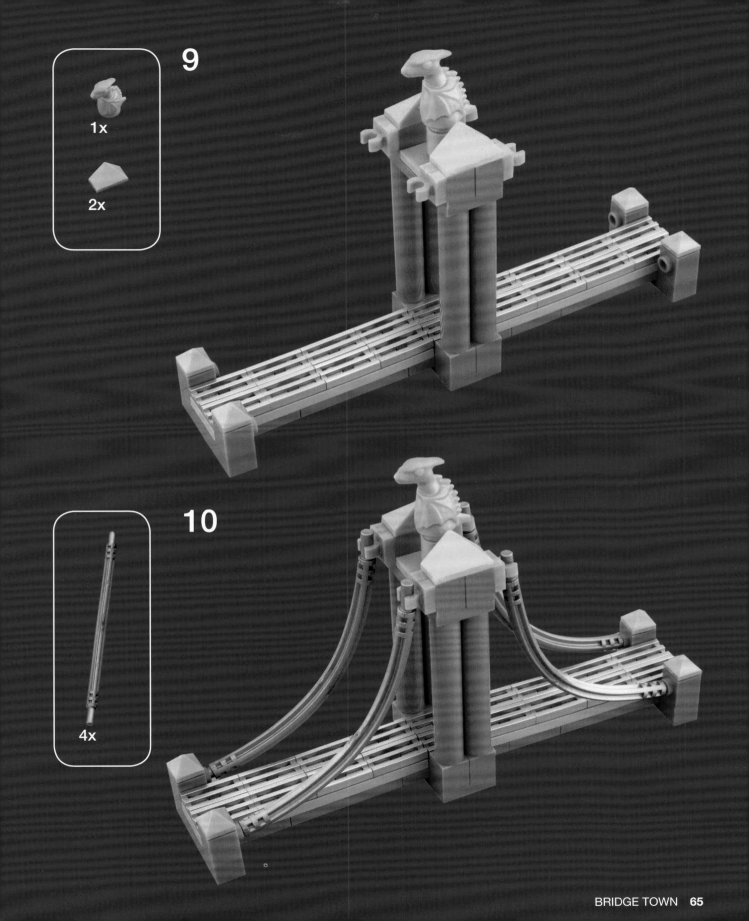

9

1x

2x

10

4x

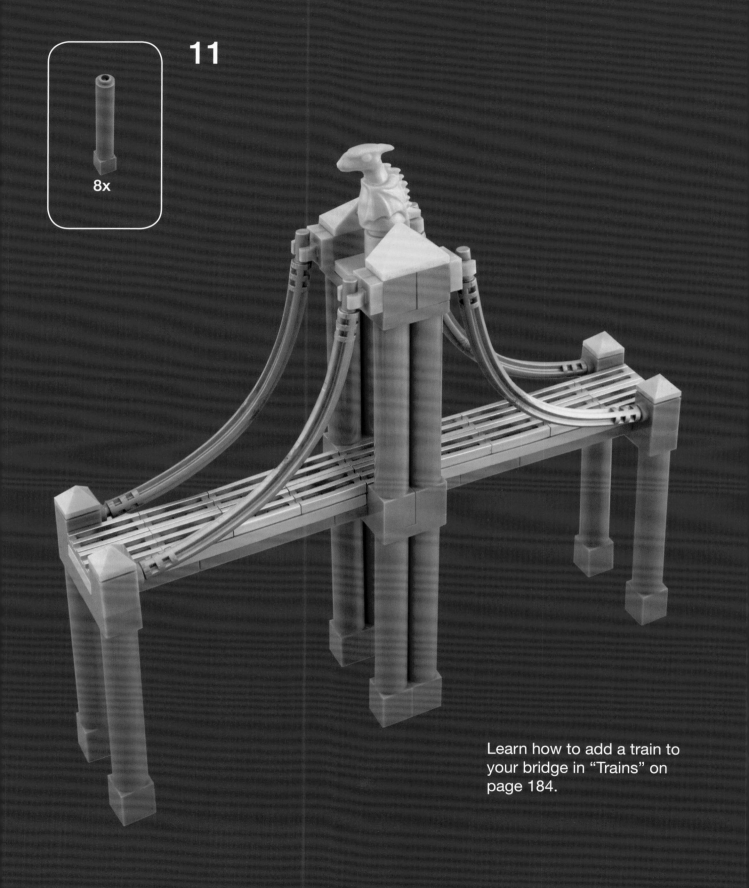

11

8x

Learn how to add a train to your bridge in "Trains" on page 184.

MAKE IT YOUR OWN

Customize the look of your bridge by changing the gold ornaments on top. Why not make a bridge dedicated to the humble river-dwelling frog instead of a dragon?

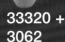

33320 + 3062

98383

90389

4073 + 4589

2343

3062

15470

33291

3069

You can turn this rail bridge into a road bridge by replacing grille tiles with regular tiles. You could even make one lane for trains and the other for cars.

30104

Chains can replace the soft axle hoses used for the suspension cables. You could also do without suspension at all and have a mid-supported plank bridge instead.

SHADES OF GREY

If you decide to build a grey bridge, you'll have a wider variety of parts to choose from. This bridge uses horizontal clips to attach fancy golden railings to its sides and features double arches on the middle tower.

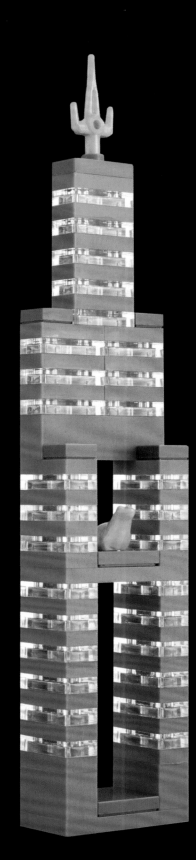

GLASS HOUSE CONDOMINIUMS

In the Glass House Condominium building, throwing stones is explicitly prohibited according to bylaw 398. It is also illegal to throw pianos out the window, so passionate musicians should take note.

The Glass House Condominiums are built using a simple but highly versatile method of stacking 1×2 plates. Alternating transparent plates with plates in a solid color can produce a wide array of architectural forms. A technique doesn't need to be complicated to be effective.

1x	1x	1x	1x	4x	1x
98139	3068	87580	3794	3070	33320

2x	1x	2x	31x	29x
3023	3010	3004	3023	3023

1

2x 1x

1x

2

12x

12x

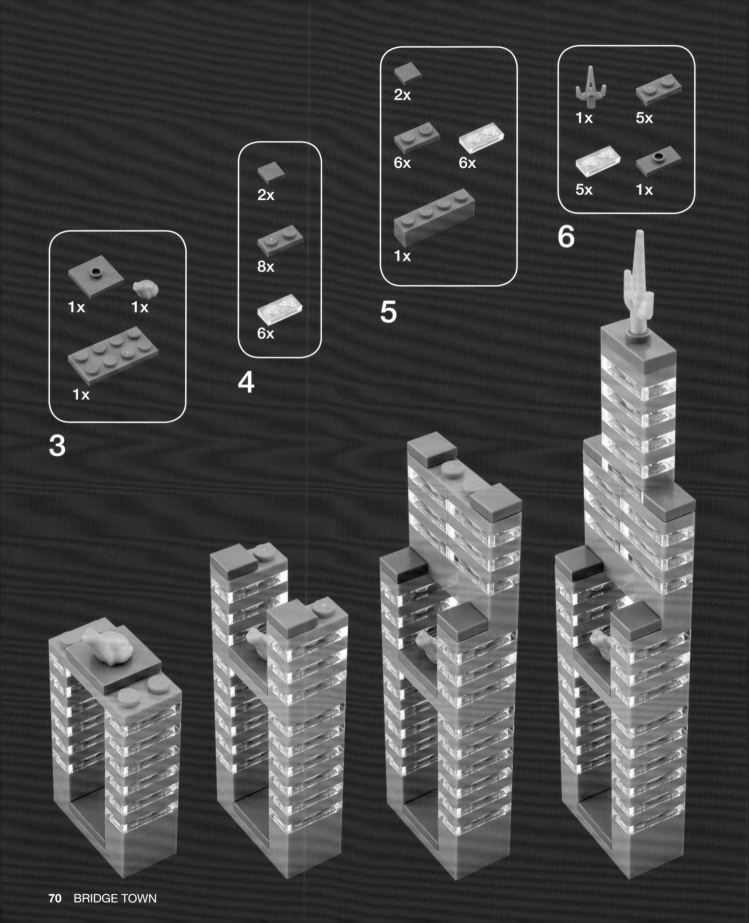

3

1x 1x

1x

4

2x

8x

6x

5

2x

6x 6x

1x

6

1x 5x

5x 1x

MAKE IT YOUR OWN

You can rearrange the plates in infinite ways. In fact, a mathematician named Søren Eilers calculated that six 2×4 LEGO bricks can be combined in 915,103,765 different ways. Just imagine what you can do with 60 1×2 plates!

Because 1×2 plates are common pieces, they can be found in almost every color. That includes rare colors such as sand green, dark azure, and the dark orange you see here.

Here are five other ways to build the Glass House Condominiums. Remember: not every building in your city needs to be an architectural wonder. In fact, utilitarian buildings can make your showstoppers stand out even more.

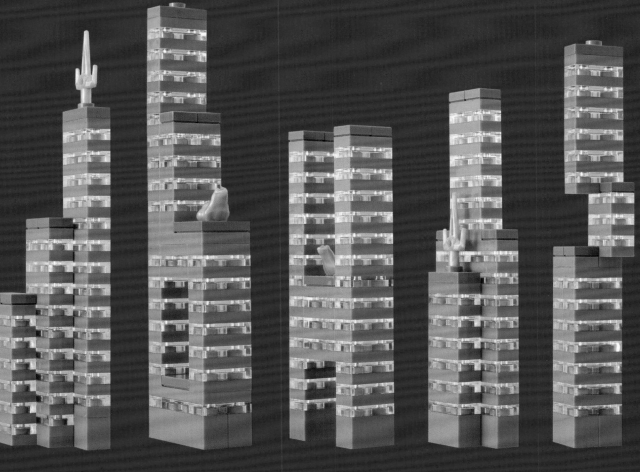

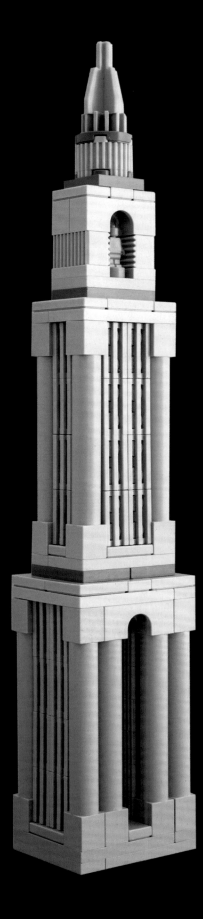

THE CLOUDSCRAPER

The Cloudscraper got its name from ironworkers who installed the building's mooring mast during a series of squalls. The mast seemed to scrape rain out of the clouds as they swooshed past. The soaked ironworkers began using the word *cloudscraper* instead of skyscraper, and the name stuck.

In this build, we use jumper plates to make a skyscraper that gets narrower as it gets taller, which is known as a *setback* or *step-back skyscraper*.

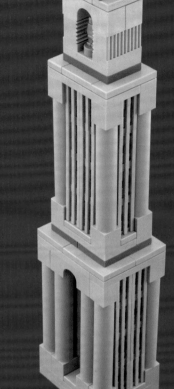

12x	1x	1x	1x	10x	2x	1x
43888	4869	92947	15535	3069	3070	90389

4x	5x	12x	2x	2x	8x	2x
4490	3004	2877	11211	87087	3005	47905

3x	1x	3x	1x	4x	2x	1x	32x
3031	3021	3021	3022	87580	3023	3794	2412

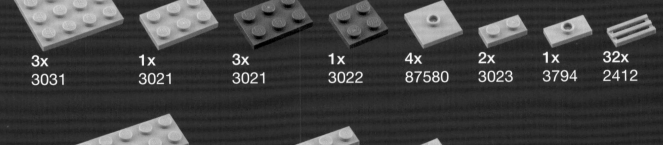

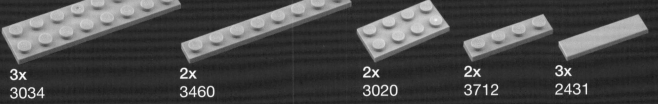

3x	2x	2x	2x	3x
3034	3460	3020	3712	2431

1

2x

2x

2

2x

1x

3

2x

12x

4

2x

16x

Attach the 2×8
plates to the
side-facing studs
on each side.

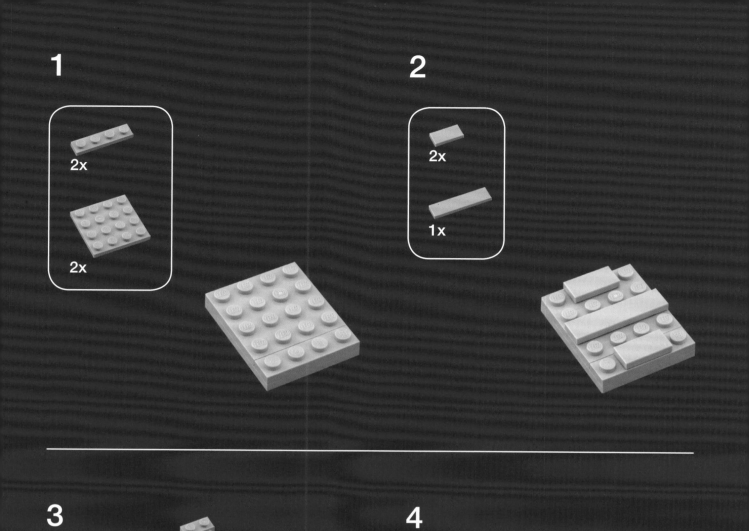

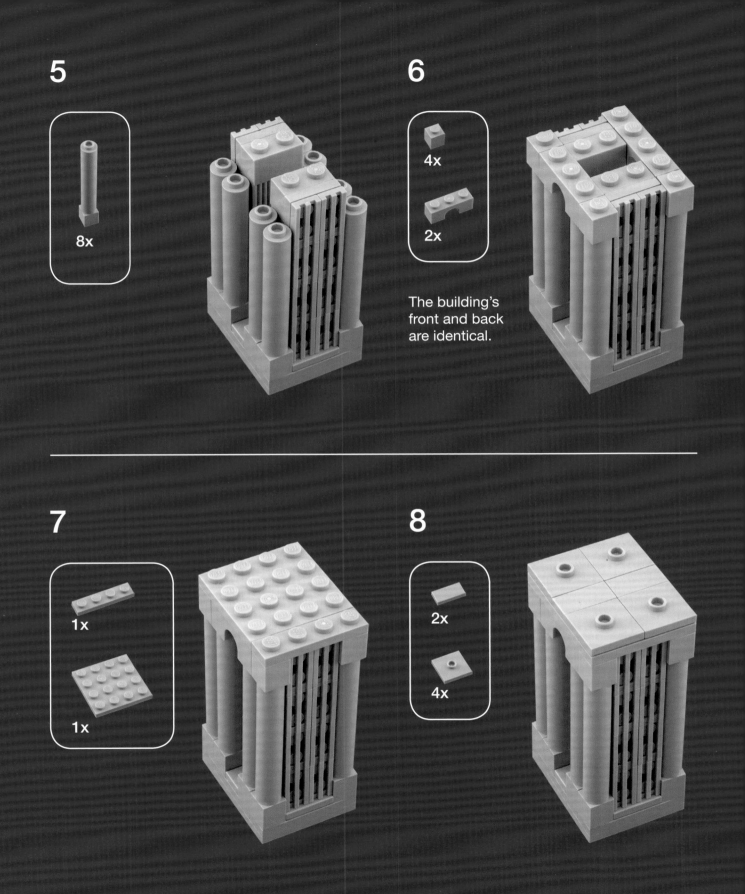

5

8x

6

4x

2x

The building's
front and back
are identical.

7

1x

1x

8

2x

4x

9

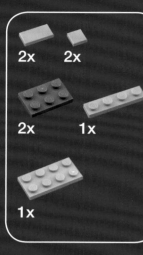

2x 2x

2x 1x

1x

10

1x 1x

1x

11

1x

1x

1x

Combine the plates and grille tiles to make the building's windows in step 12.

12

Attach the four plates you built in step 11 to the side-facing studs on the building's center. Then attach the 1×8 plates to the narrower sides, and attach the 2×8 plates to the front and back.

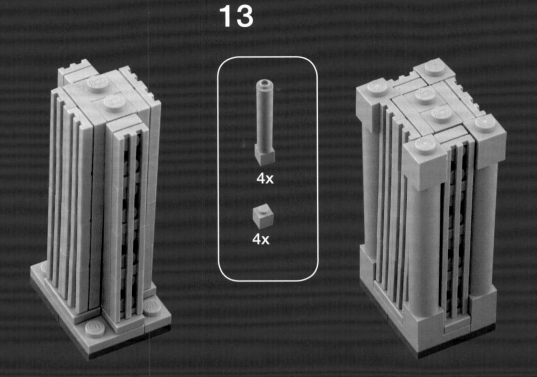

13

14

1x

1x

15

2x

1x

2x

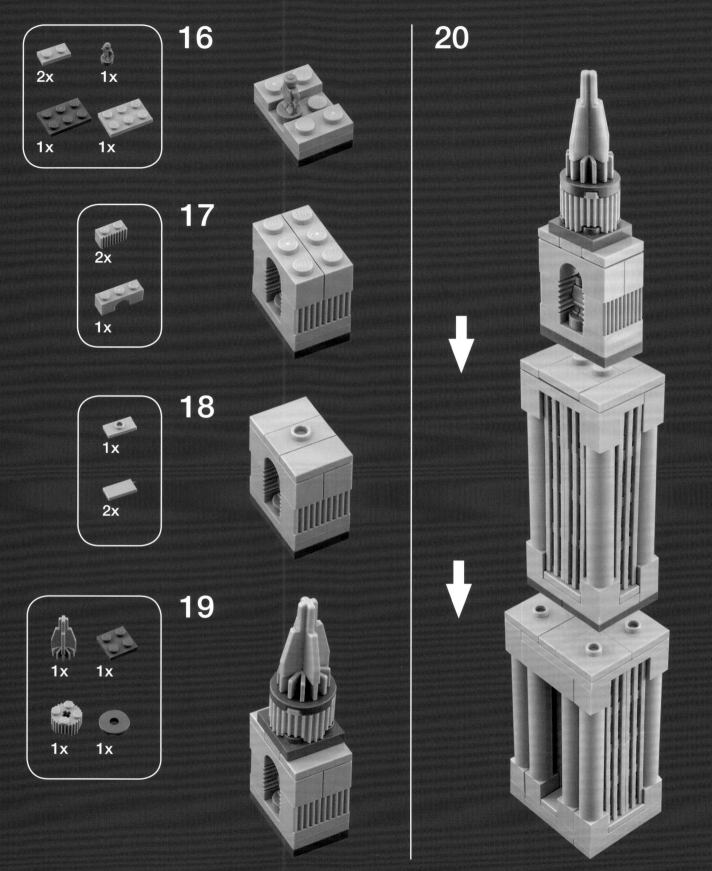

16

2x 1x

1x 1x

17

2x

1x

18

1x

2x

19

1x 1x

1x 1x

20

MAKE IT YOUR OWN

The Cloudscraper has a tall narrow arch on the bottom floor that you can run a road or railroad through. You could even run two levels of transportation through the arch if your city demands it.

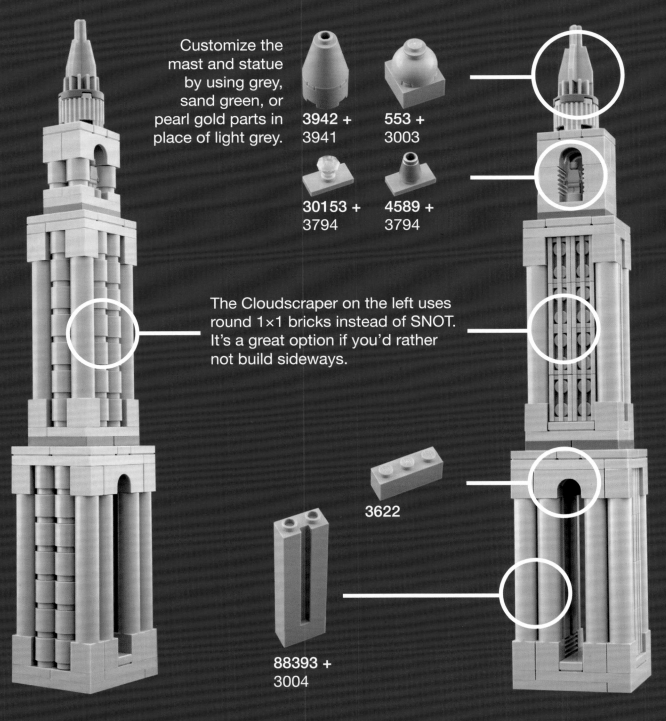

Customize the mast and statue by using grey, sand green, or pearl gold parts in place of light grey.

3942 + 3941

553 + 3003

30153 + 3794

4589 + 3794

The Cloudscraper on the left uses round 1×1 bricks instead of SNOT. It's a great option if you'd rather not build sideways.

3622

88393 + 3004

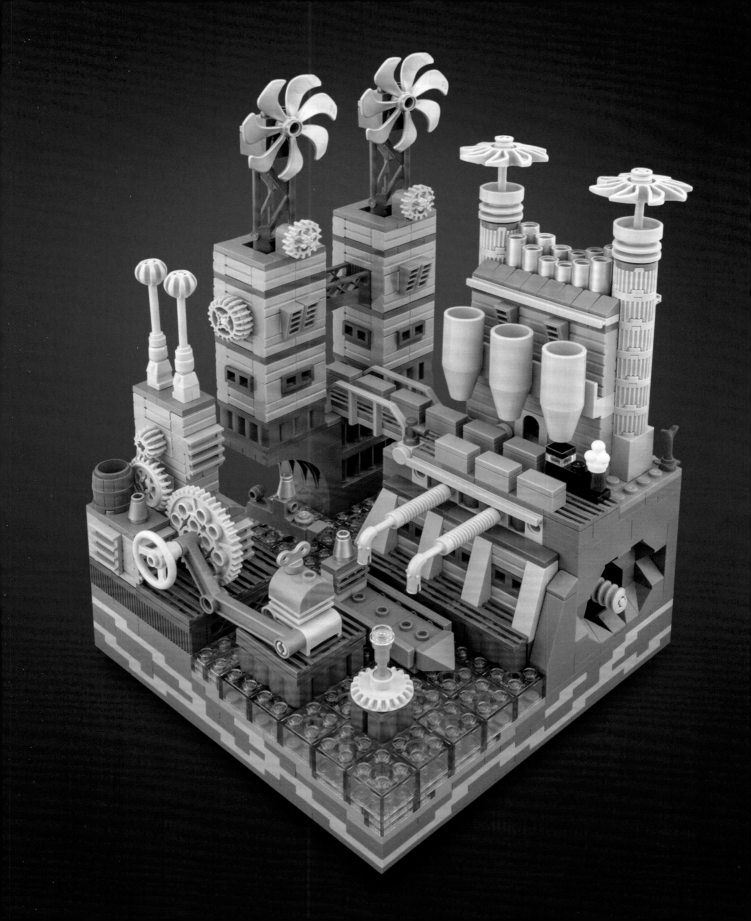

STEAMWORKS

If you can overlook the smog, hard labor, and environmental catastrophes of the Industrial Age, the era is a rich source of architectural inspiration. Massive brick factories loomed overhead like the great temples of antiquity. Their maze-like complexity and imposing bulk towering over the smoky skyline inspired awe in onlookers.

This LEGO micro city gives the industrial era a steampunk spin for added fun. *Steampunk* is a style inspired by the first science-fiction novels from the late 1800s, which featured steam-powered technology, considered cutting-edge at that time. A steampunk theme liberates your city from strict realism and lets you explore fantastical designs.

Generous use of LEGO Technic gears quickly establishes an industrial theme, along with any brick that can be used as a chimney. This city uses windmills in an effort to run on clean-power technology, but unfortunately, the wind is generated from coal-fired hot air.

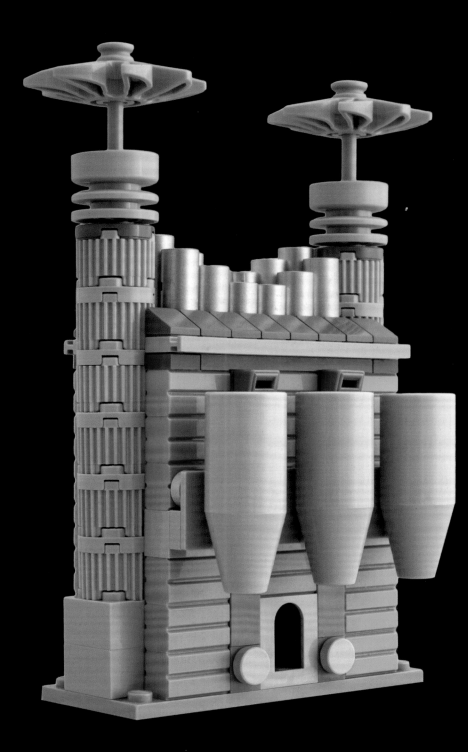

S & C MUSIC FACTORY

The S & C Music Factory's chimneys are built like organ pipes. When the factory is at maximum efficiency, it plays J.S. Bach's Toccata and Fugue.

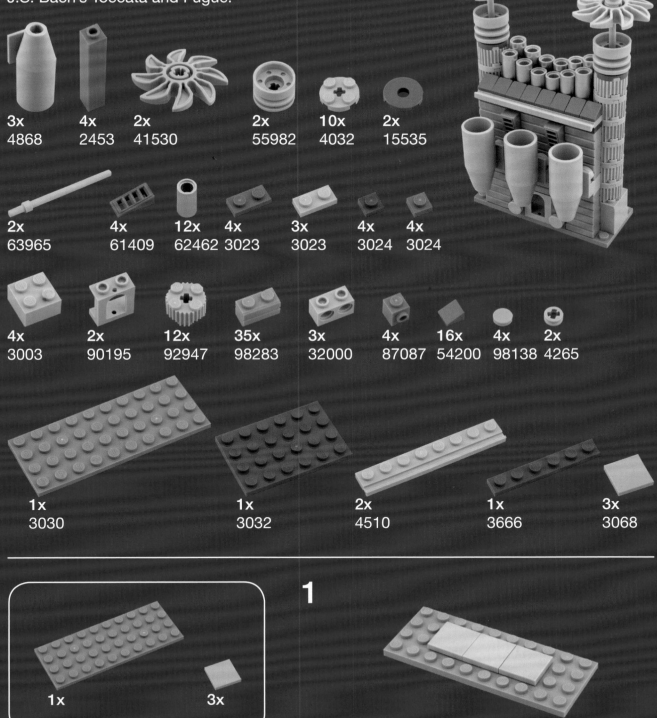

3x 4868
4x 2453
2x 41530
2x 55982
10x 4032
2x 15535

2x 63965
4x 61409
12x 62462
4x 3023
3x 3023
4x 3024
4x 3024

4x 3003
2x 90195
12x 92947
35x 98283
3x 32000
4x 87087
16x 54200
4x 98138
2x 4265

1x 3030
1x 3032
2x 4510
1x 3666
3x 3068

1

1x
3x

2

4x 2x

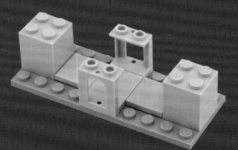

3

19x

Note that the
middle stack
is five bricks
tall while the
side stacks are
seven bricks tall.

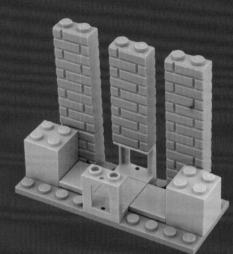

4

16x 3x

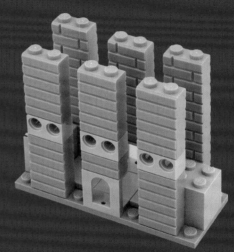

5

4x 8x

4x 4x

You'll need to build four of these columns.

6

3x

7

3x 6x

Attach two round tiles to each aircraft engine.

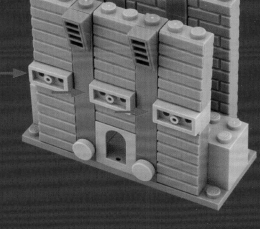

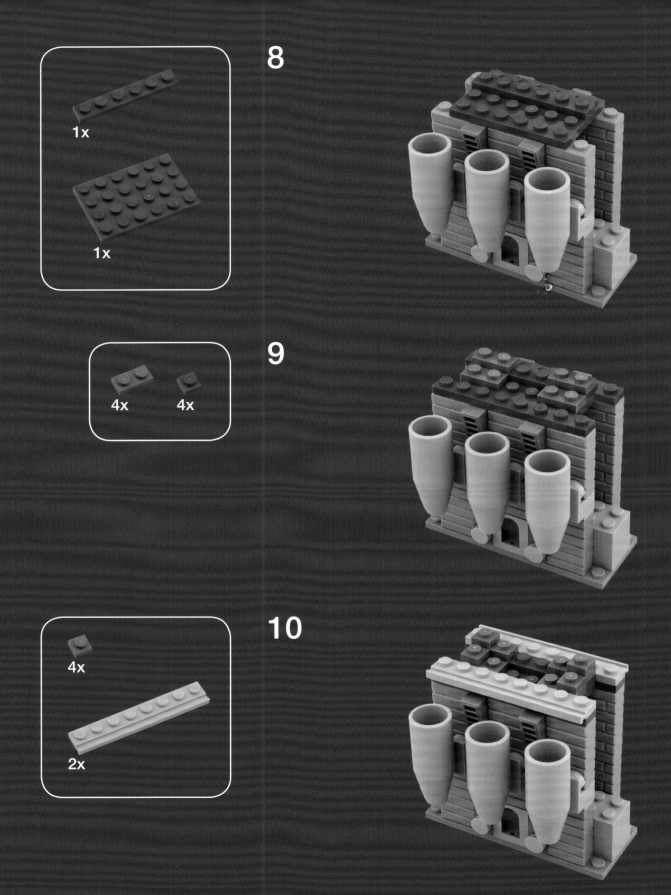

8

1x

1x

9

4x 4x

10

4x

2x

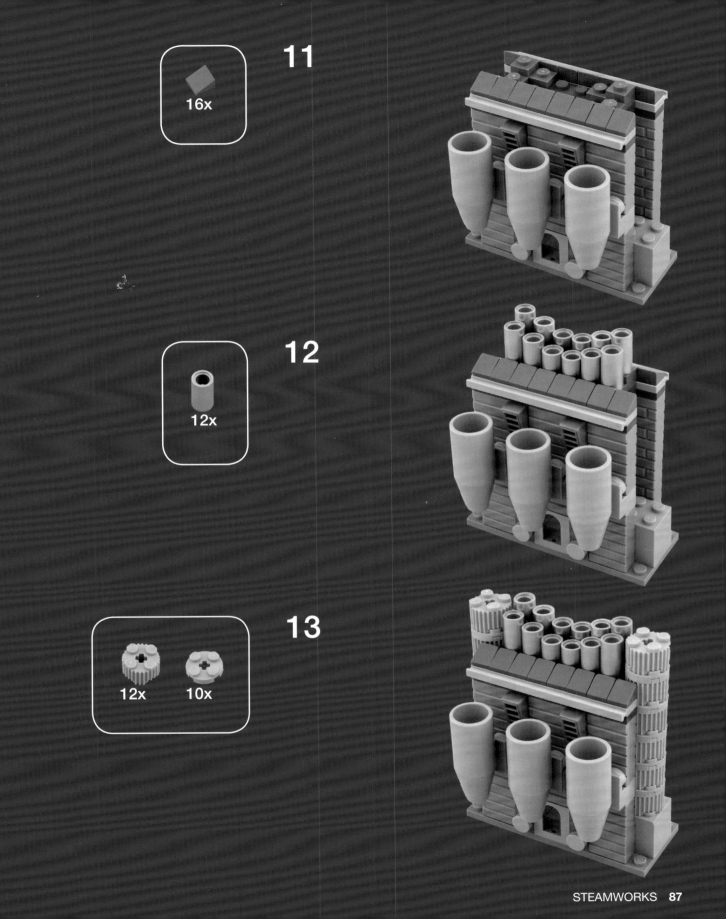

11

16x

12

12x

13

12x 10x

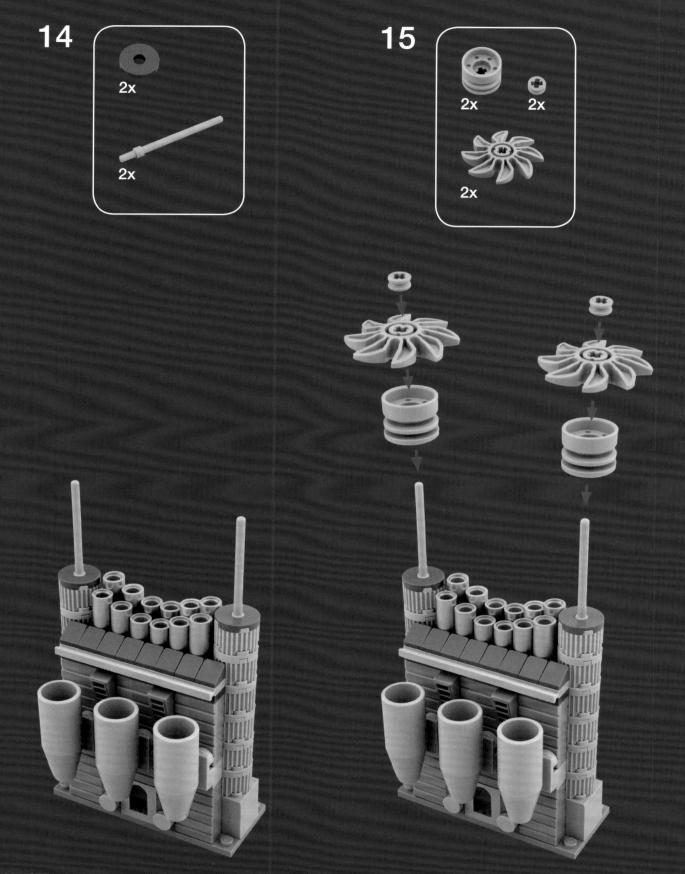

MAKE IT YOUR OWN

The S & C Music Factory has aircraft engine silos on just one side to fit on a 20×20-stud city. But if you have enough space in your city, you can have silos on both sides. Just omit step 3 and repeat steps 4 through 7 for both sides of the building.

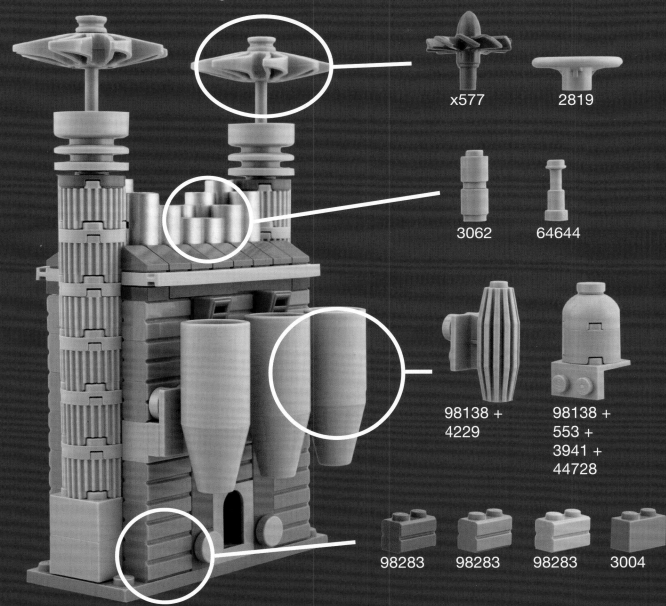

x577

2819

3062

64644

98138 + 4229

98138 + 553 + 3941 + 44728

98283

98283

98283

3004

FINDING INSPIRATION

The S & C Music Factory doesn't conform to any architectural style, and that's what makes it interesting! Its design is inspired by a pipe organ. Seek inspiration in unexpected places.

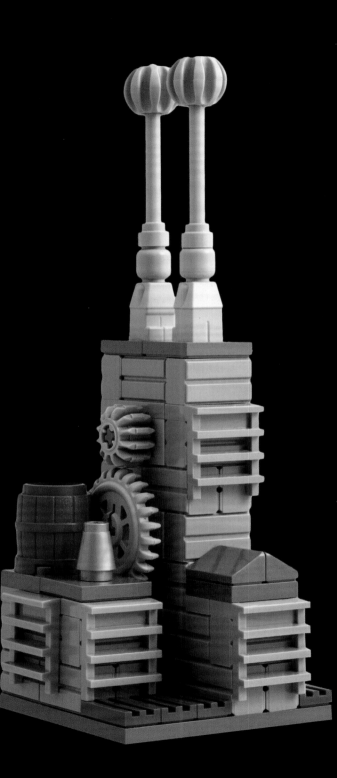

THE LIGHTNING FOUNDRY

Electricity crackles between the Lightning Foundry's two positively charged spheres, in an ill-advised scheme to create nighttime lighting for the city. You'll recognize Lightning Foundry workers by their hair, which stands on end and makes them look constantly surprised.

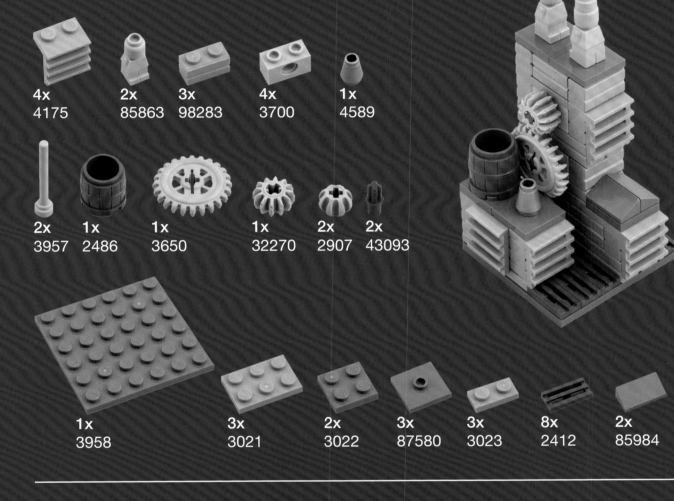

4x
4175

2x
85863

3x
98283

4x
3700

1x
4589

2x
3957

1x
2486

1x
3650

1x
32270

2x
2907

2x
43093

1x
3958

3x
3021

2x
3022

3x
87580

3x
3023

8x
2412

2x
85984

1

1x

8x

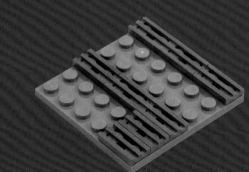

2

12x

3

4x

4

2x 2x

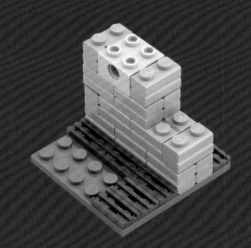

5

4x

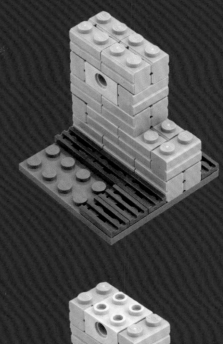

6

2x 2x

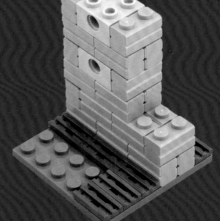

7

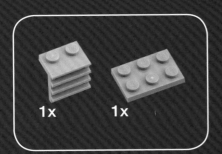

1x 1x

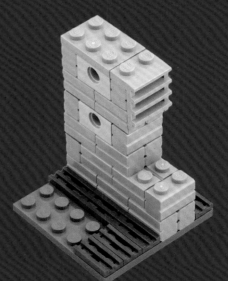

8

4x 2x

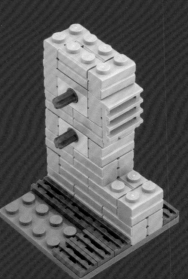

9

1x 1x

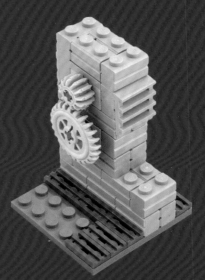

10

1x 8x

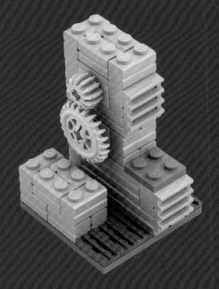

11

2x 2x

12

1x

3x 2x

13

1x 1x

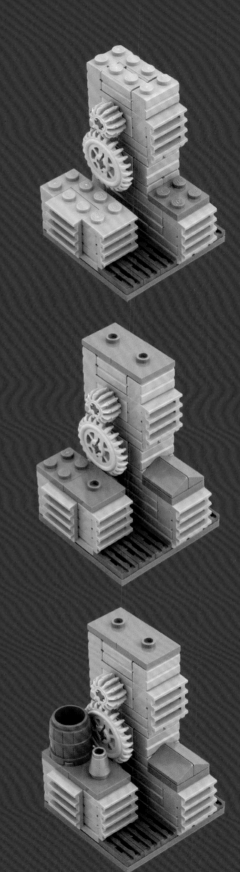

14

FORM FOLLOWS FUNCTION?

"Form follows function" is a maxim of modernist architects, who view ornamentation as gratuitous excess. But form doesn't always follow function, and surprisingly decorative elements can be found on the most serious industrial buildings. For example, London's Battersea Power Station, a former coal-fired power plant and one of the largest brick buildings in the world, has chimneys that were made to resemble fluted Roman columns.

MAKE IT YOUR OWN

Transform your city into a complete industrial complex by connecting buildings with Technic gears. You can fine-tune the placement of gears using plates to alter their height.

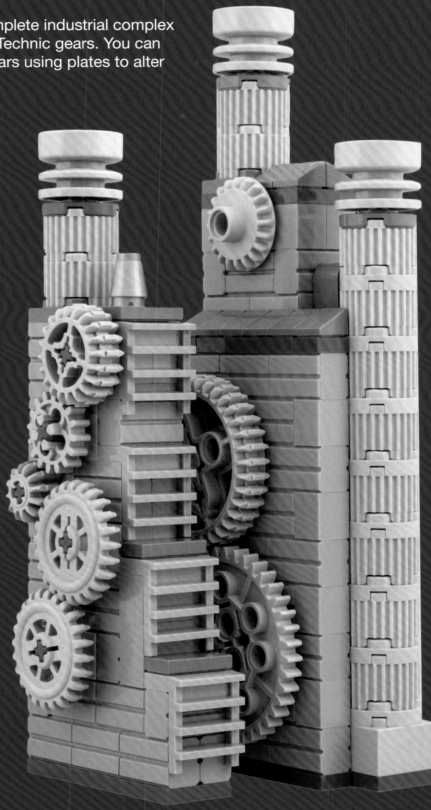

GEARING UP

Technic gears often make up a humble component in a LEGO Technic vehicle's transmission or engine. But in microscale, these gears become massive wheels of industry that tower overhead and roar like thunder.

Mix and match any gears in your collection and place them on your industrial buildings to keep production rolling.

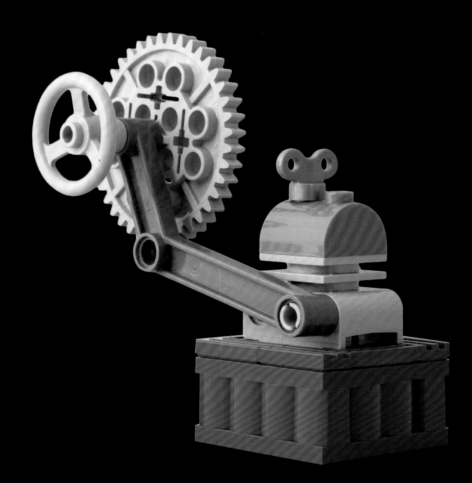

FLYWHEEL

The Flywheel features a gargantuan gear that spins using steam from boiling seawater. The gear can power up a large factory, and it also makes an effective paper shredder.

This gear is on a movable arm that can rotate 180 degrees. Simply rest the Flywheel gear on top of another building's gear to power it up.

2x
3031

1x
30165

2x
30137

2x
30136

6x
2412

1x
98375

1x
3673

1x
64451

1x
3649

1x
2850

1x
2819

1x
4519

1

1x **2x** **2x**

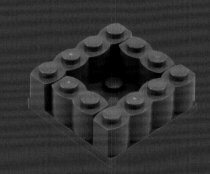

2

1x 6x

3

1x 1x 1x 1x

4

1x 1x

1x 1x

5

MAKE IT YOUR OWN

Use any 1×1 round brick to add a custom chimney to the Flywheel's domed roof.

The only thing more enjoyable than one giant gear on a movable arm is two giant gears on two movable arms! You can add even more arms since there are attachments for four gears in total.

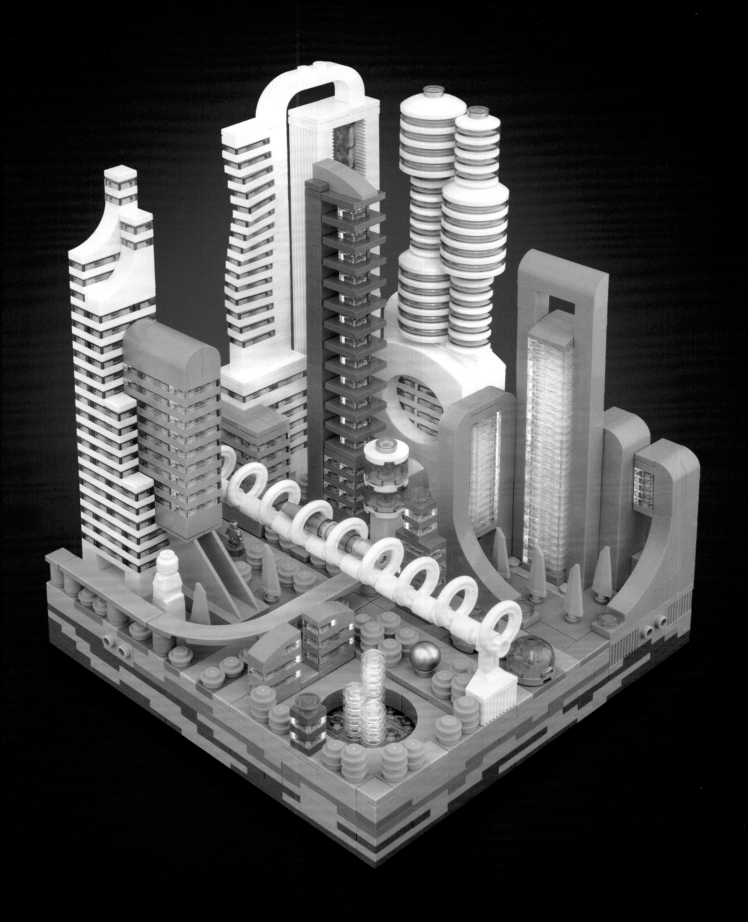

HYPERLOOP CITY

The main attraction of this sleek LEGO city is its next-generation Hyperloop technology, which uses electromagnetic rings to propel glass-walled passenger pods. It can transport passengers at speeds exceeding 600 miles per hour. Best of all, the open-air Hyperloop alleviates the claustrophobia of traveling in a closed tube. When you've built a beautiful LEGO city, why not give your citizens a clear view of its wonders?

Your LEGO micro city's mode of public transportation says a lot about the city. For example, steam-driven trams, electric subways, or gleaming monorails clearly reveal the era you've placed your city in. A Hyperloop shows the world that your city is run by a visionary who embraces cutting-edge technology.

Public transportation and technological innovation are crucial to a thriving city. Will you embrace the future or get left behind?

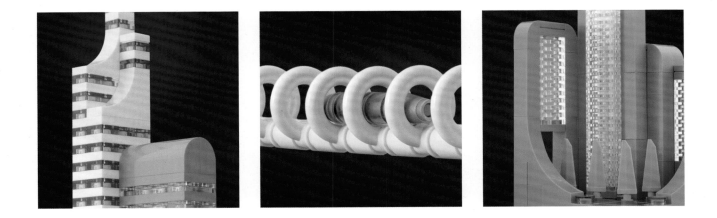

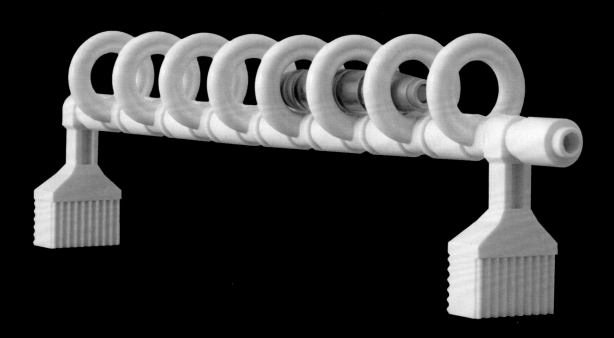

THE HYPERLOOP

This Hyperloop transports your citizens in style and shows off your city's technical prowess.

You'll use minifigure life preservers to re-create these microscale loops. Then, use R2-D2's legs to hold the Hyperloop up. (Don't worry—R2-D2 can use his rocket boosters to get around.)

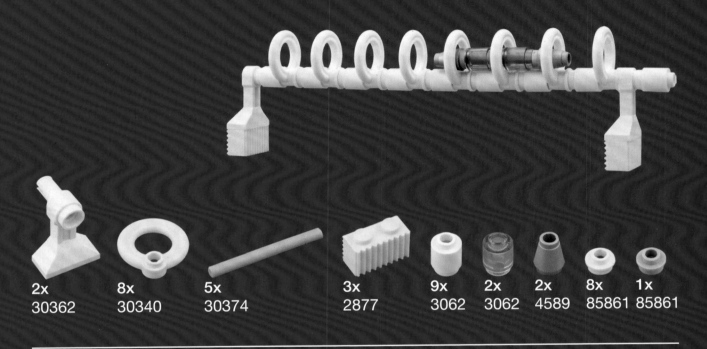

2x	8x	5x	3x	9x	2x	2x	8x	1x
30362	30340	30374	2877	3062	3062	4589	85861	85861

1

1x

1x

2

2x 2x

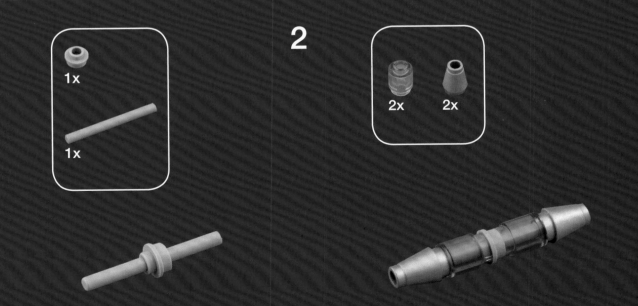

3

1x **1x**
1x **1x**

4

1x **1x**
1x

4x

5

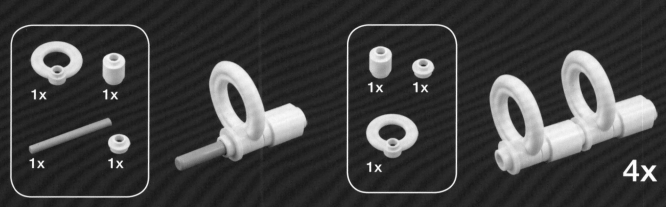

6

2x **1x**

2x

Note that the passenger pod from step 2 doesn't attach to the track, allowing you to simply push the pod into the rings from either end. The rings prevent it from derailing.

MAKE IT YOUR OWN

Make a totally enclosed Hyperloop with basic bricks in place of minifigure life preservers. You can also give R2-D2 his legs back and use 1×1×3 bricks instead. If you don't have any 1×1×3 bricks, stacking three 1×1 bricks will work just as well.

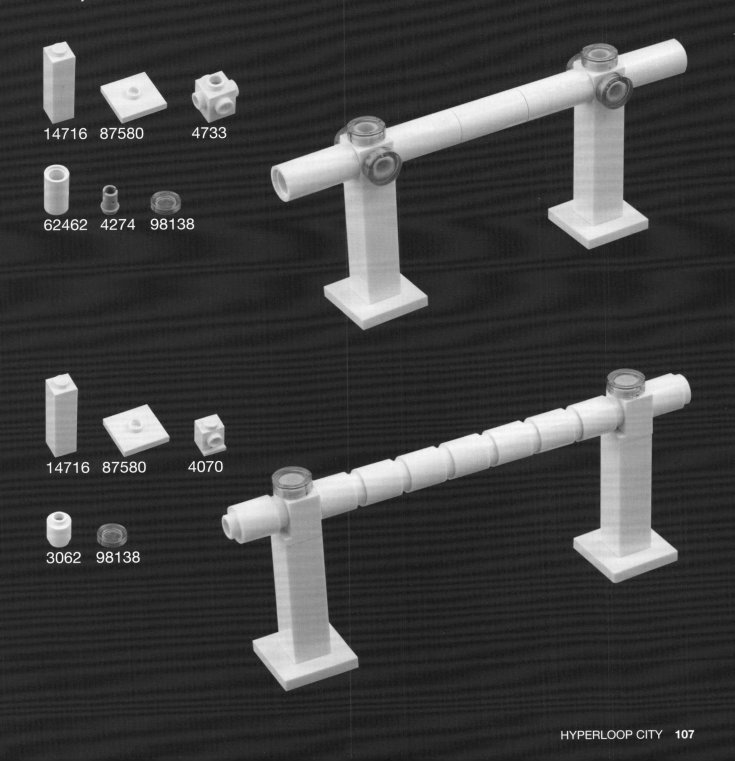

14716 87580 4733

62462 4274 98138

14716 87580 4070

3062 98138

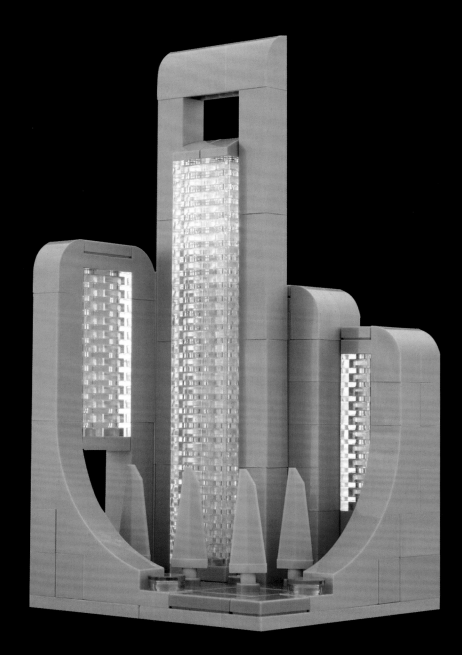

BLUE SWAN SUITES

The Blue Swan Suites offer their residents an impeccably stylish and graceful lifestyle. Medium azure is an uncommon color, but this build's abstract design works within the limitations in available parts.

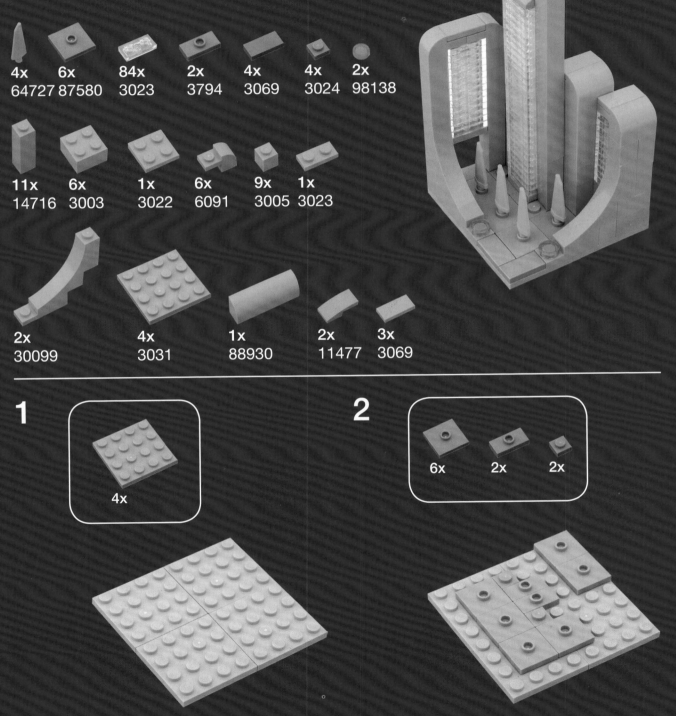

4x 64727
6x 87580
84x 3023
2x 3794
4x 3069
4x 3024
2x 98138

11x 14716
6x 3003
1x 3022
6x 6091
9x 3005
1x 3023

2x 30099
4x 3031
1x 88930
2x 11477
3x 3069

1

4x

2

6x 2x 2x

3

2x

4x

4

3x

5

1x 1x

6

1x

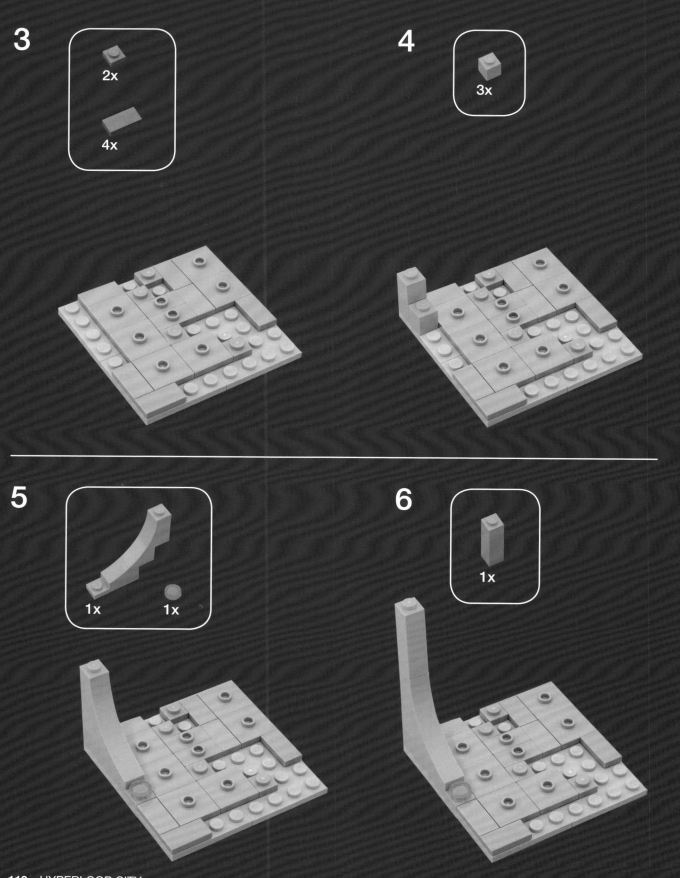

7

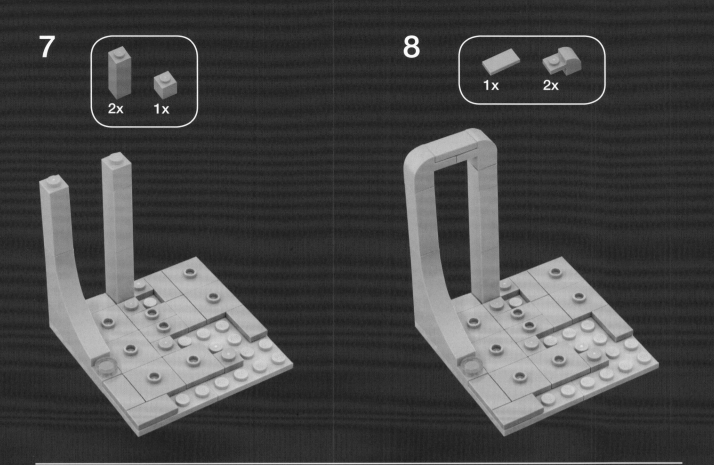

2x 1x

8

1x 2x

9

14x

1x

Stack the 14 transparent plates on top of the azure one, and then attach the entire stack to the underside of the arch.

The connection should be sturdy enough, but it's not supported from below. For added support, use more plates to build all the way to the ground floor, removing the 1×2 tile on the base plate.

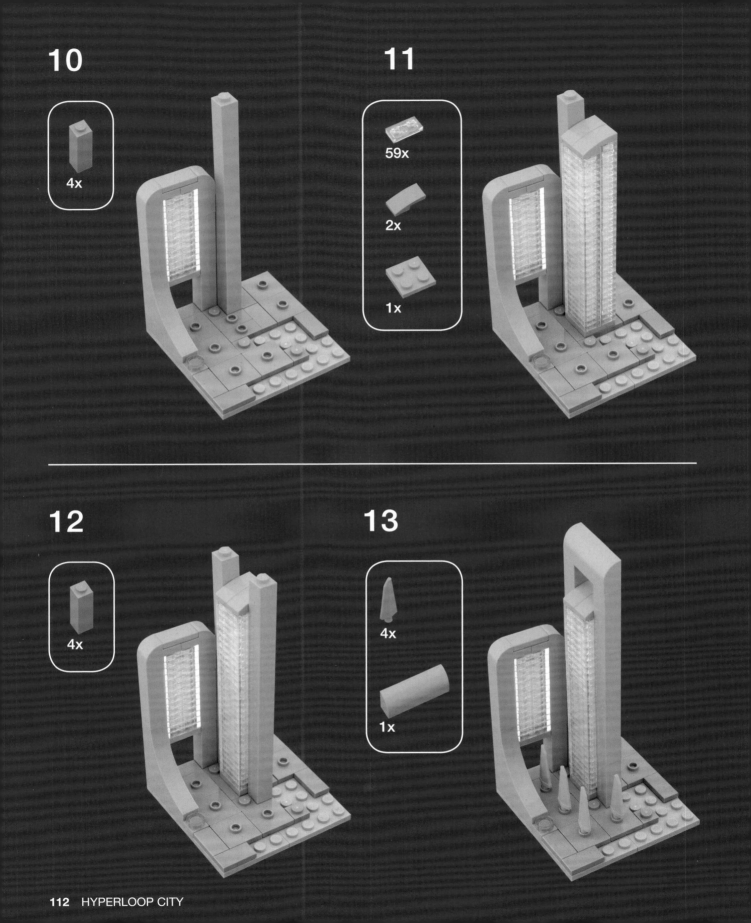

10

4x

11

59x

2x

1x

12

4x

13

4x

1x

14

6x

2x

15

2x

1x

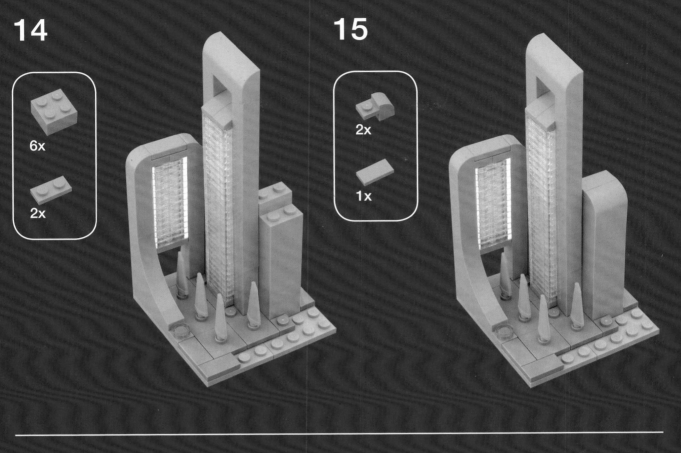

16

1x

2x

17

11x

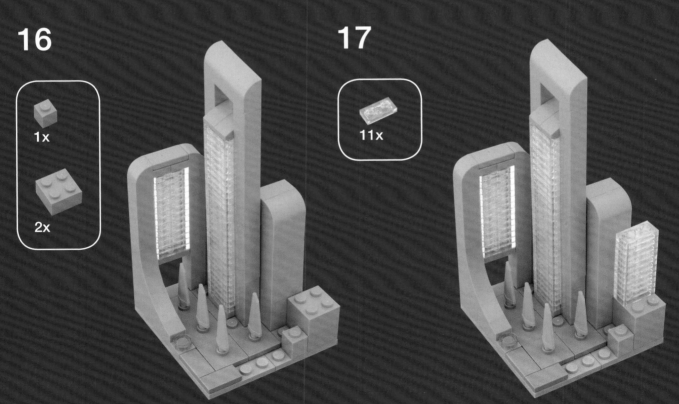

18

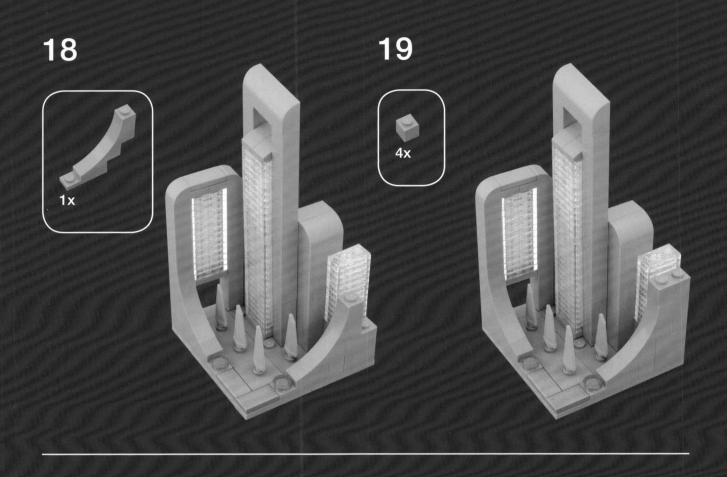

1x

19

4x

20

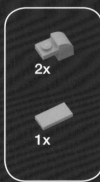

2x

1x

BRICK SKETCHING

Limitations are good for creativity. For example, the Blue Swan Suites design resulted from trying to work around the limited assortment of parts available in medium azure.

An effective method for designing new buildings is to gather a limited selection of bricks for *brick sketching*, or attaching bricks together in different configurations with no particular plan in mind. You never know what beautiful shapes might emerge from a free-form build.

MAKE IT YOUR OWN

The trees are optional. You can leave the jumper plate's hollow stud empty to create a microscale pool or round bench.

2431

3941

3941

3004

3005

4073

85863

33183 +
85861

89522 +
85861

4073 +
4073

98138 +
4073

If you can't find enough parts in medium azure, use another color.

You can also replace the 59 1×2 plates in the central tower with 11 2×2 round bricks. Also, you can replace the windows on the side wings with 1×1 round plates to continue the circular window look.

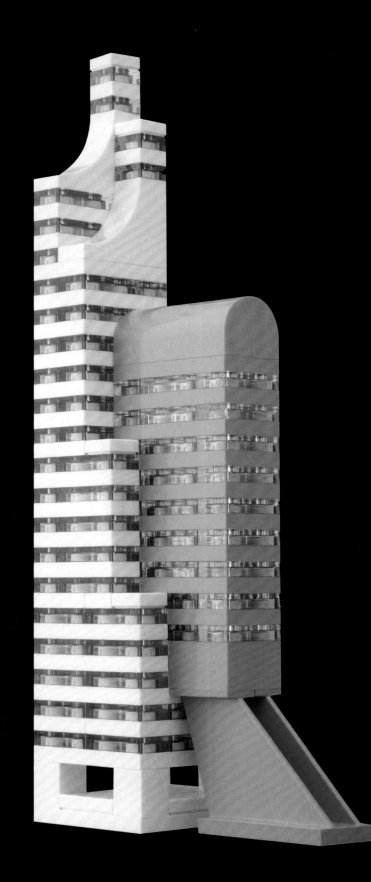

CORPORATE MERGER

The merger of Maglev Motors and Pickled Pretzels went smoothly, except that neither business wanted to leave its respective office headquarters. In a feat of diplomacy and engineering, the two office buildings were fused together—giving corporate synergy a whole new meaning.

This building uses a minifigure-scaled airplane tail fin to re-create a microscale architectural support. Always be on the lookout for how a minifigure-scaled part might work as an architectural feature.

3x
3004

4x
3005

36x
3023

53x
3023

7x
3024

2x
18653

2x
87580

1x
63864

4x
3069

5x
3070

2x
2340

2x
88930

1x
3001

9x
3020

4x
3031

1x
3020

7x
3021

4x
3710

10x
3623

3x
3023

3x
64727

1

4x

1x **4x**

1x

2

12x

2x

3

1x

1x

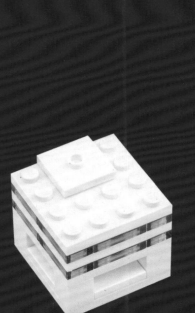

4

12x

4x

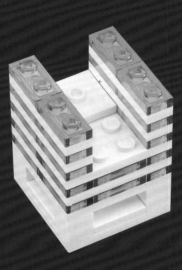

5

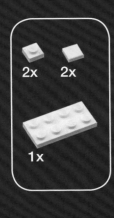

2x 2x

1x

6

4x

7

4x

4x

8x

8

3x

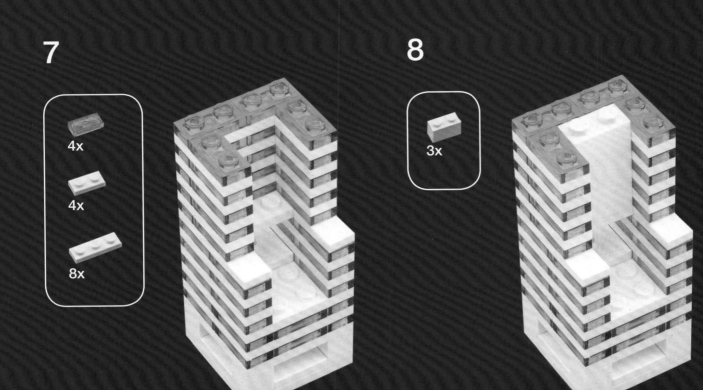

9

1x

1x

1x

10

18x

6x

11

3x

3x

2x

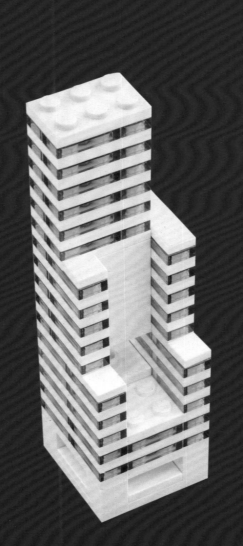

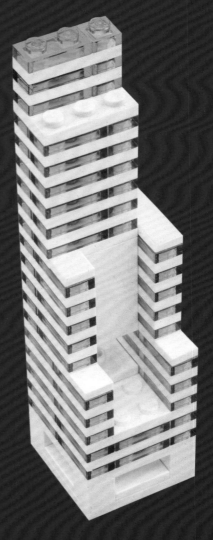

12

2x

13

2x **4x** **2x**

14

1x **4x**

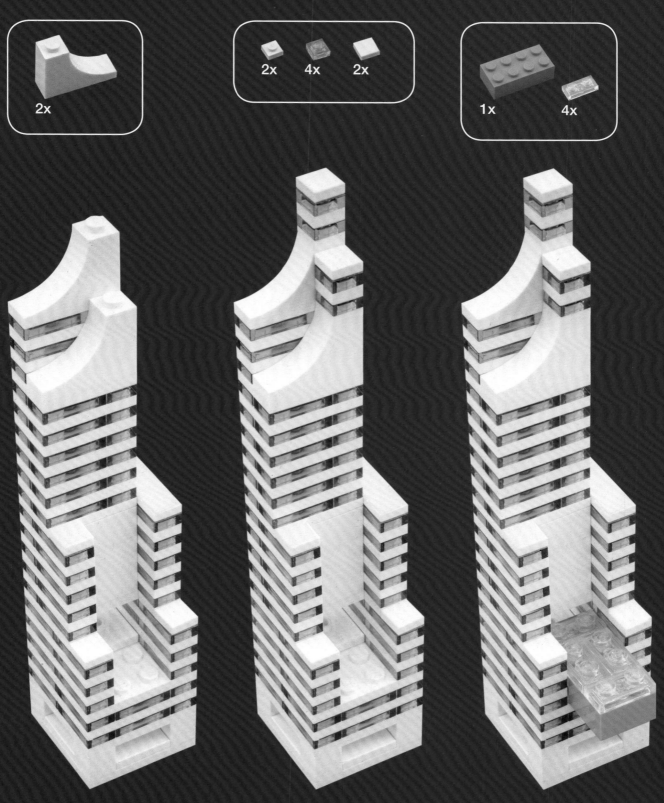

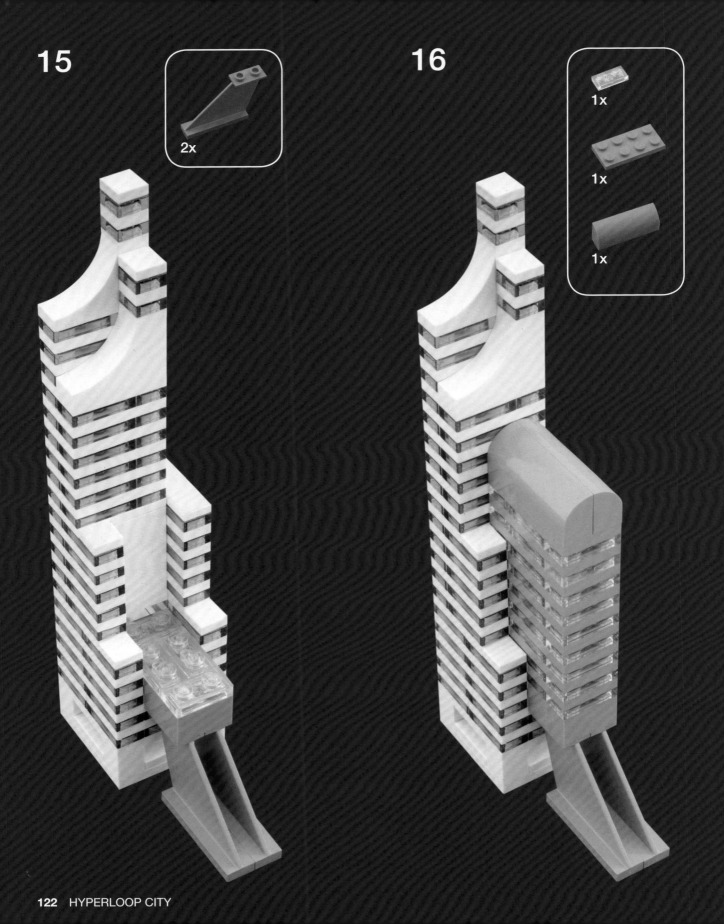

MAKE IT YOUR OWN

Don't be afraid to become a LEGO DJ and remix these pieces to come up with new, unexpected variations.

The formula to generate a LEGO DJ name is as follows: MC + (your favorite LEGO color) + (the last LEGO piece you stepped on).

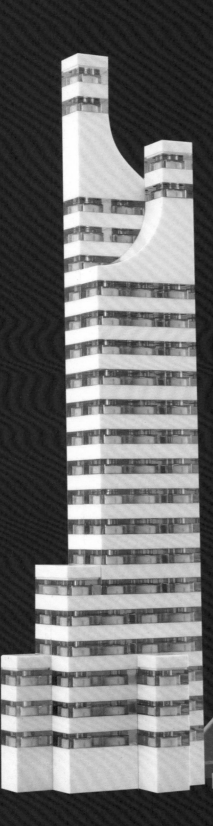

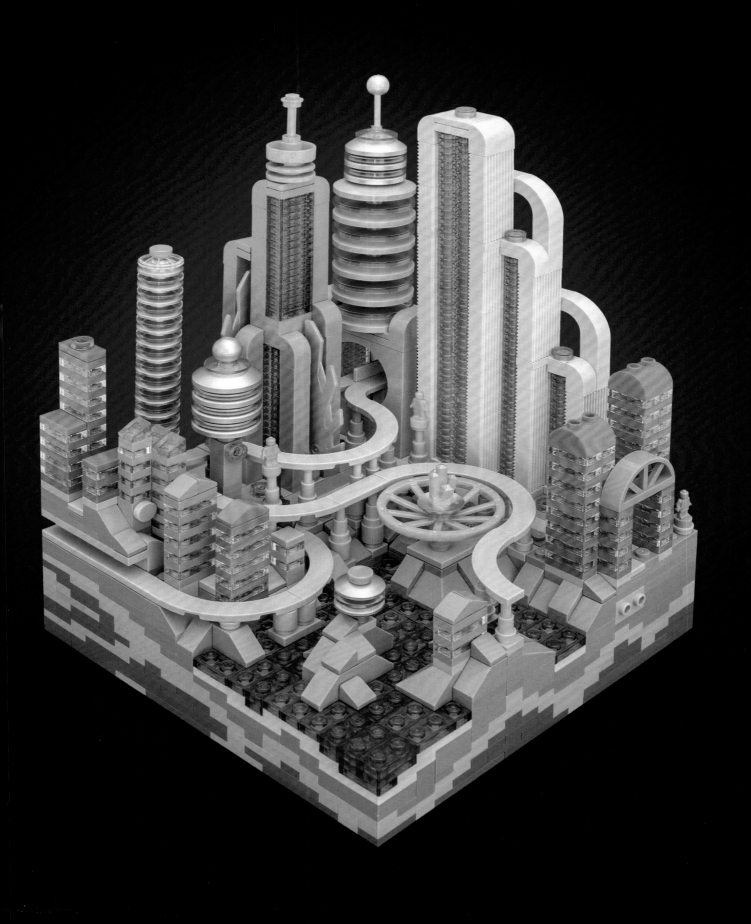

TOMORROWLAND

Why wait for the future? You can use LEGO to build tomorrow's cities today.

Tomorrowland is inspired by a retrofuturist style known as *Googie architecture*, reflecting the heady optimism spurred on by the Space Age into the 1960s. With its rounded corners, large windows, and geometric shapes that appear to be in motion, Googie architecture puts a friendly face on the future. If a building looks like it could blast off into space, it's probably Googie. The Theme Building at Los Angeles International Airport is a perfect real-world example.

Tomorrowland features elevated roadways made with LEGO's new curved tiles and minifigure telescopes. Its traffic plan is based more on aesthetics than logic, as everything Googie should be. Generous use of rounded elements, such as dishes and curves, makes for streamlined shapes, and windows built with transparent bricks give Tomorrowland's citizens a great view of the city.

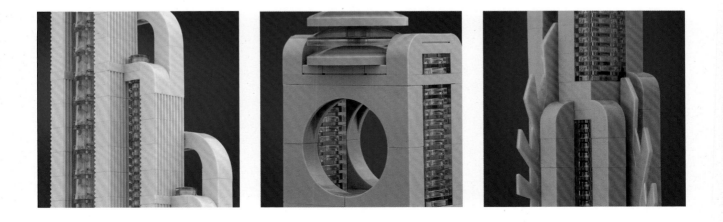

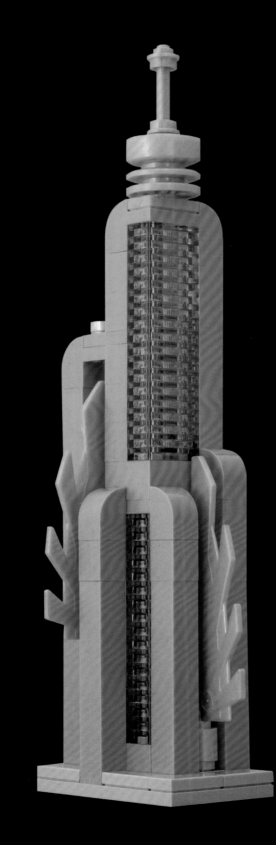

THE GOLDWING

The Goldwing is renowned for its top-floor revolving restaurant, which features a panoramic view to match its panoramic prices. The wheel hub and stylized Mixel wings make a big impression in microscale.

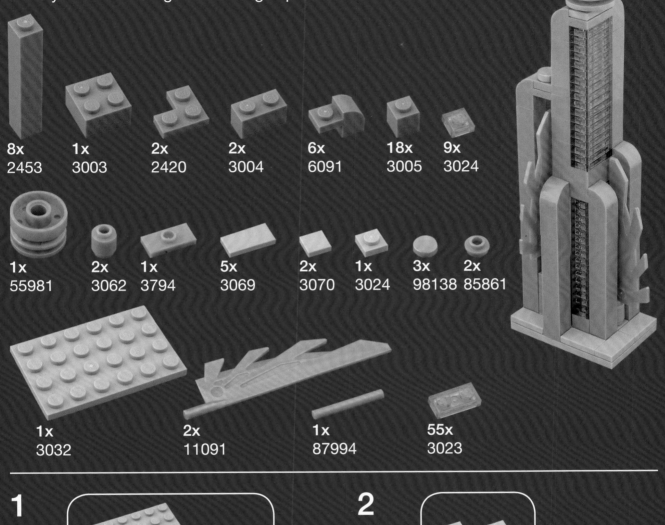

8x
2453

1x
3003

2x
2420

2x
3004

6x
6091

18x
3005

9x
3024

1x
55981

2x
3062

1x
3794

5x
3069

2x
3070

1x
3024

3x
98138

2x
85861

1x
3032

2x
11091

1x
87994

55x
3023

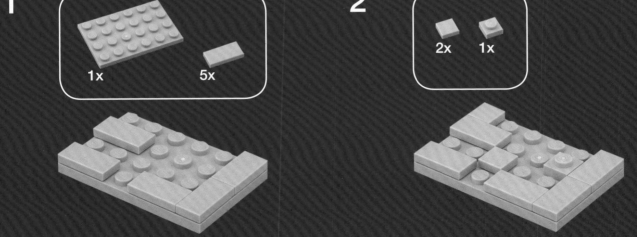

1

1x 5x

2

2x 1x

3

2x 4x 1x

4

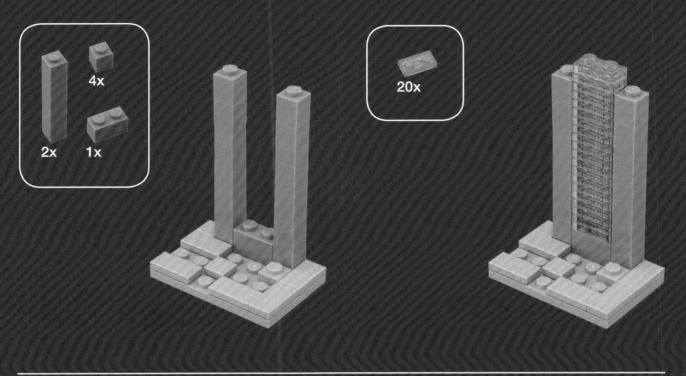

20x

5

1x 2x

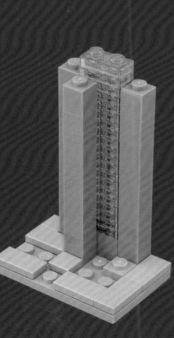

6

2x

1x 2x

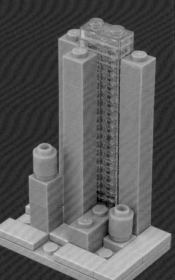

7

17x 1x

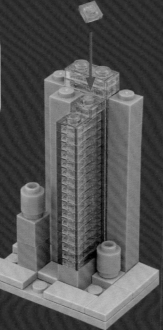

You can use a
solid-colored
1×1 plate
instead of a
transparent
one.

8

2x 2x

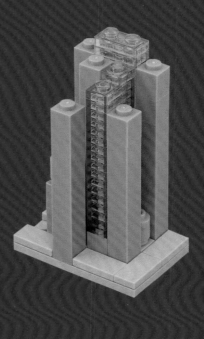

9

4x

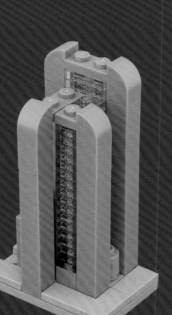

10

1x

1x

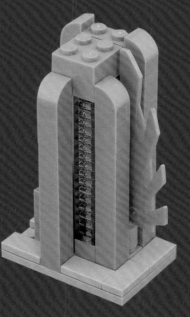

The gold wing
fits into the open
stud of the gold
1×1 round brick.

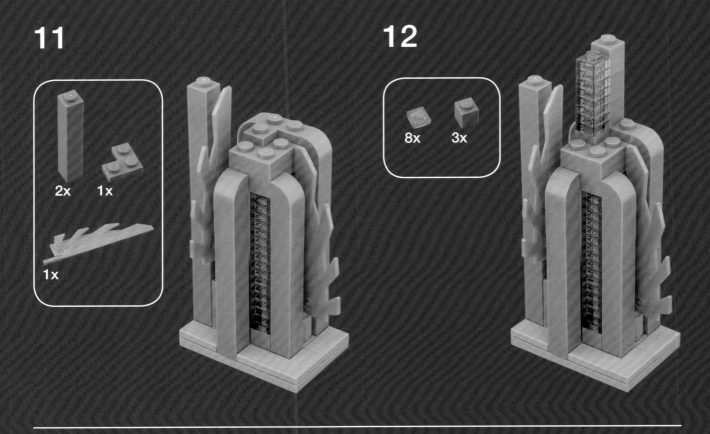

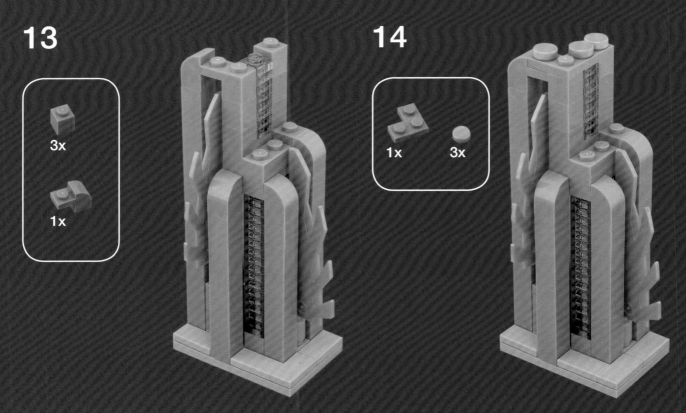

15

1x 2x

16

2x

1x 18x

17

1x 2x

1x

MAKE IT YOUR OWN

Try these Goldwing variations to inspire your own creations.

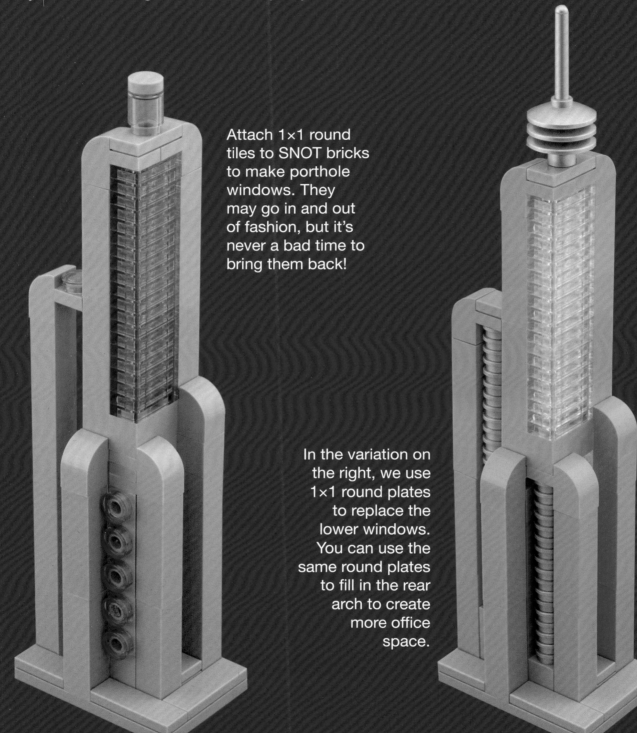

Attach 1×1 round tiles to SNOT bricks to make porthole windows. They may go in and out of fashion, but it's never a bad time to bring them back!

In the variation on the right, we use 1×1 round plates to replace the lower windows. You can use the same round plates to fill in the rear arch to create more office space.

IMPROVISING WITH BRICKS

If we can use a minifigure frying pan to top a skyscraper, then the sky's the limit for creative LEGO design. Let your bricks guide the way!

Add a subtle variation in color by combining transparent light blue 1×2 plates with transparent medium blue ones, as shown on the left.

Stack 1×2 bricks in alternating colors to make convincing microscale windows.

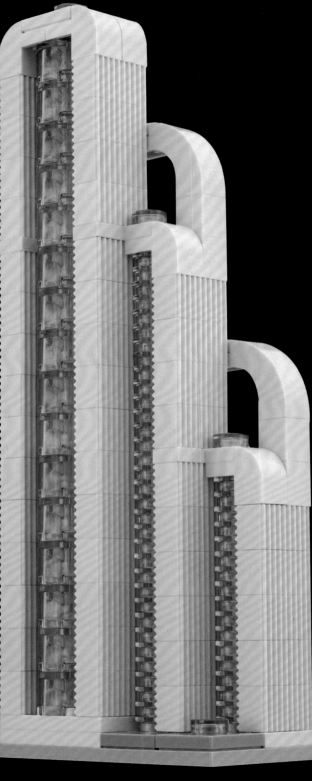

THE STREAMLINER

The showstopping Streamliner enhances Tomorrowland's skyline with its whimsical arches.

2x
14716

2x
6005

2x
87580

16x
3941

4x
98138

50x
4073

34x
2877

4x
2420

6x
6091

4x
3005

1x
3023

2x
3069

3x
2453

1x
3035

2x
3020

1x
87580

6x
3069

1x
3024

1

1x

2x 1x

1x

2

5x

3

2x 1x 1x

Stack two 2×4
plates on top
of each other.

4

5x

5

17x

6

6x 1x

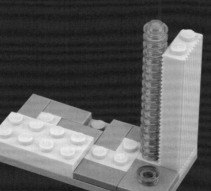

7

4x

1x

Use a
corner plate
to connect
the walls
and add
stability.

8

33x

9

11x

1x

10

1x

1x

Add another
corner plate
on top
for extra
strength.

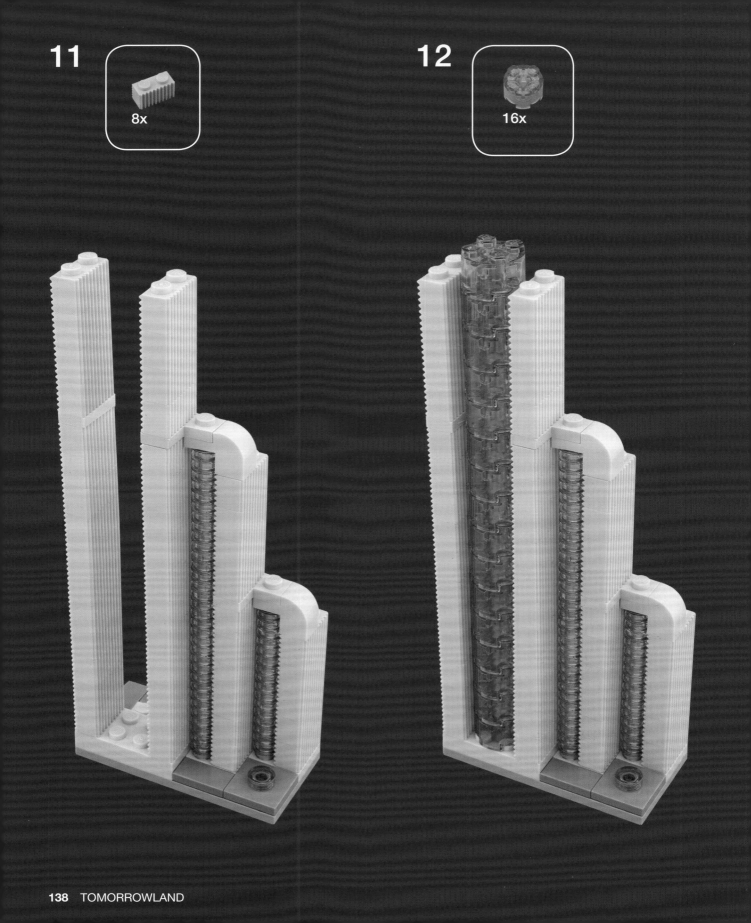

13

4x

14

1x 3x

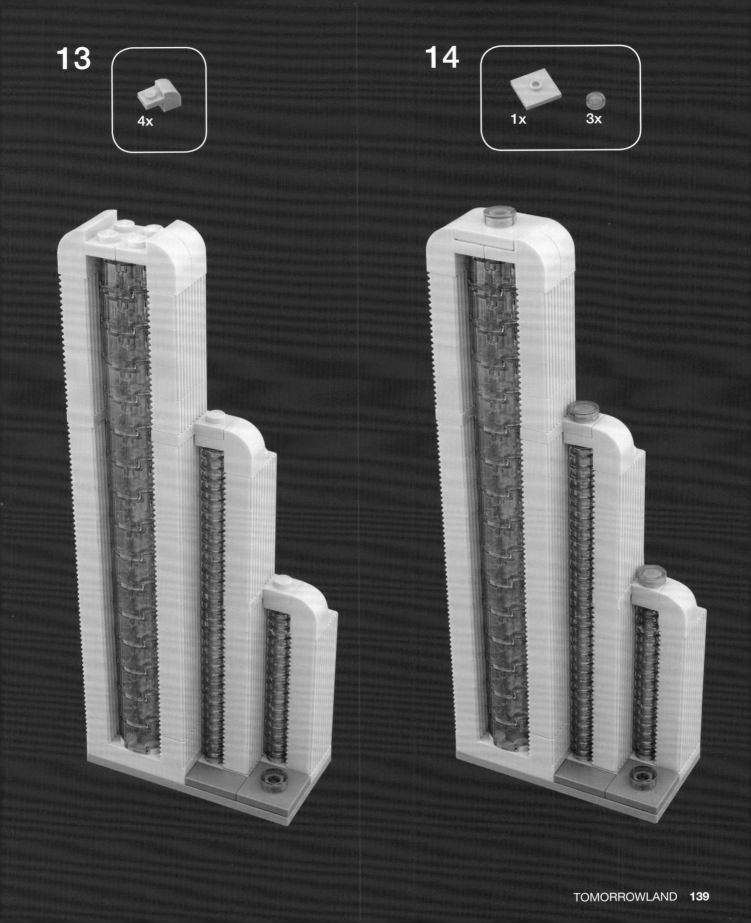

15

16

Spin the build-
ing around
180 degrees
to continue
working on
the other side.

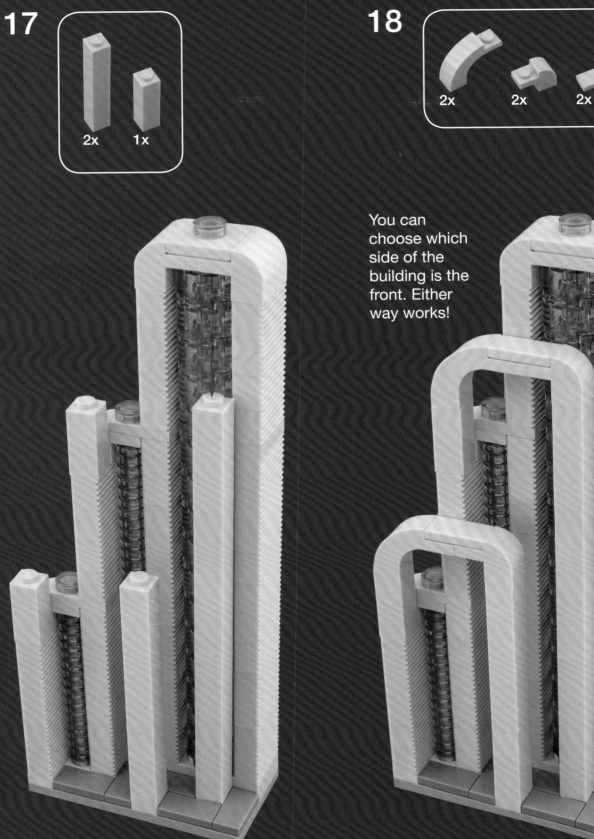

17

2x 1x

18

2x 2x 2x

You can
choose which
side of the
building is the
front. Either
way works!

MAKE IT YOUR OWN

The Streamliner you see here doesn't totally match the one shown in the introduction of this chapter. While the original Streamliner uses 192 round plates in the tallest tower, this version is more economical, using only 17 2×2 round bricks to build the same tower—a good option if you don't have 192 round plates at your disposal.

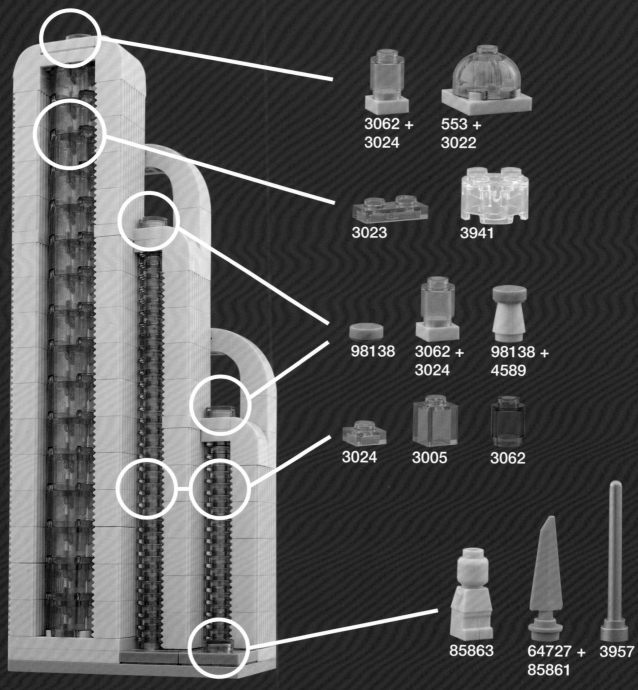

3062 +
3024

553 +
3022

3023

3941

98138

3062 +
3024

98138 +
4589

3024

3005

3062

85863

64727 +
85861

3957

BALANCING ACT

Rebuild a symmetrical version of the Streamliner, or do the opposite and take the asymmetry even further.

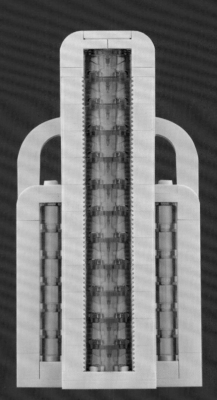

SYMMETRY

A common element in architecture, symmetry can convey a sense of strength, balance, and dependability, but it can also make buildings look static and predictable.

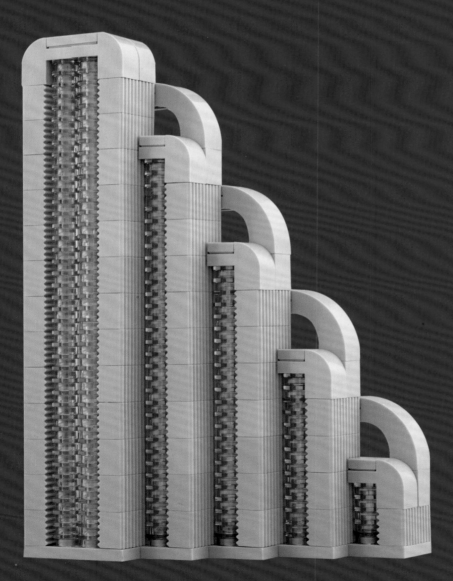

ASYMMETRY

Asymmetry in architecture can be visually dynamic, but it requires more planning to ensure all of the elements balance and harmonize with each other. You may have to experiment and rebuild if necessary. There is no correct formula, but sticking to a consistent pattern can help give some continuity to your build. In this example, each arch is exactly two bricks taller than the one below it.

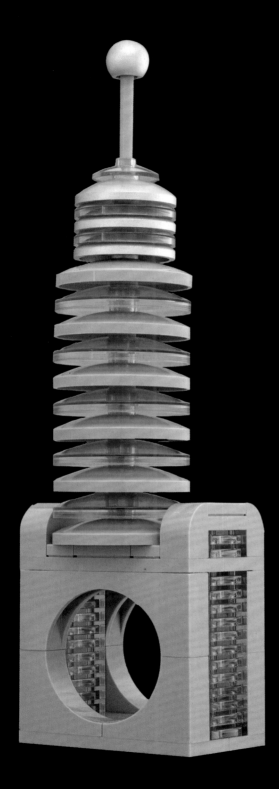

3.14 CIRCLE DRIVE

This well-rounded building offers office space, rent-controlled apartments, and an indoor llama petting zoo.

Stacking dish pieces adds a futuristic touch to your builds.

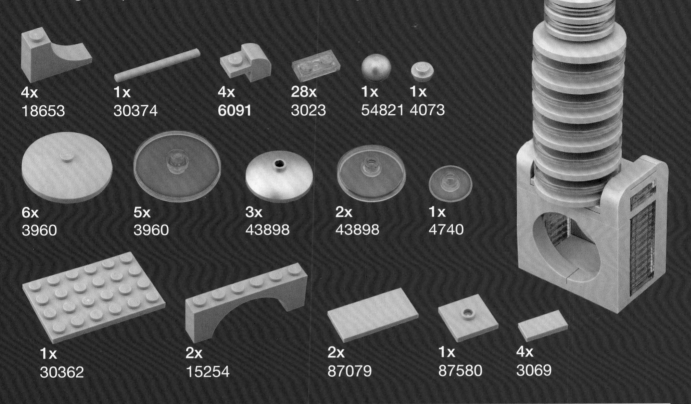

4x 18653	1x 30374	4x 6091	28x 3023	1x 54821	1x 4073

6x 3960	5x 3960	3x 43898	2x 43898	1x 4740

1x 30362	2x 15254	2x 87079	1x 87580	4x 3069

1

24x

1x

1x

2

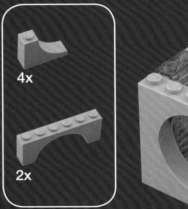

4x

2x

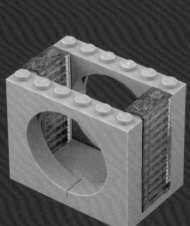

3

1x 2x

1x

4

2x 4x

4x

5

6x

5x 1x

6

1x

3x 1x

2x 1x

The 1×1 round plate in step 5 is covered up in step 6, so use any color.

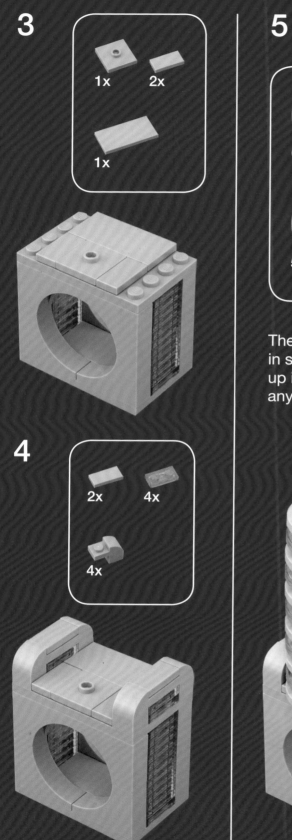

MAKE IT YOUR OWN

It's easy to change this building's height by adding or removing dishes. The 4×4 dishes can get wobbly with height, so be careful as you build up. The 3×3 dishes should be stabler.

You can remove the 2×4 tile from the ground floor to fill in the hollow circle with more transparent 1×2 plates.

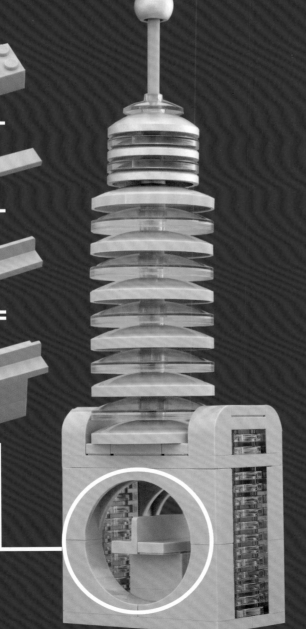

2x
3003

+

1x
2431

+

1x
30413

=

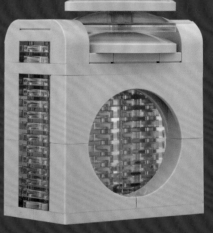

You could also add an elevated roadway that passes through the circle to connect the city's ever-expanding transportation network.

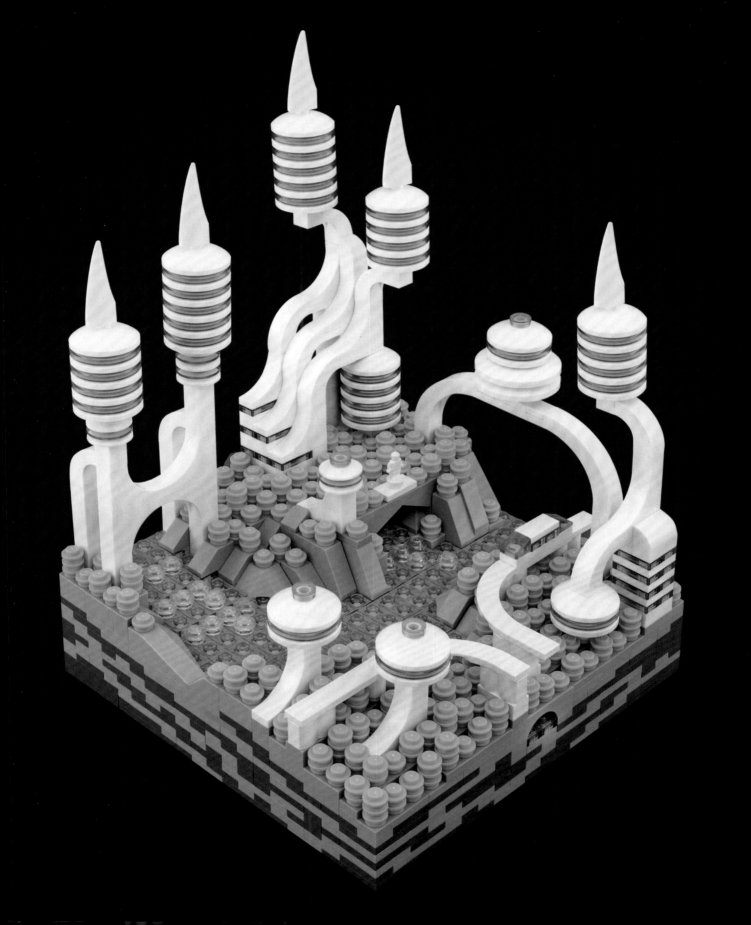

UTOPIA

The pursuit of an ideal city is as old as ancient Greece, yet it has remained an elusive goal. People have different visions about what a utopia should be. Lucky for you, you can build your own micro utopia to suit your ideals and no one else's.

This LEGO city is inspired by architect Zaha Hadid, also known as "the queen of the curve." The natural-looking curves typically found in *organic architecture* can be a challenge to replicate with LEGO, which has straight angles built into its DNA. You can mimic curves by staggering square bricks, but this leads to slightly jagged contours that resemble a pixelated image in an 8-bit video game.

Fortunately, when you build in microscale, you can take advantage of arch and disk elements to convincingly represent truly smooth curves on massive constructions.

The long-awaited inverted arch (part #18653) released in 2015 is a key component of this city. Combine the inverted arch with other arch elements, and you'll never have to build in straight lines again.

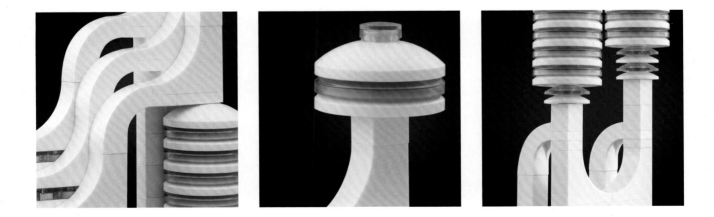

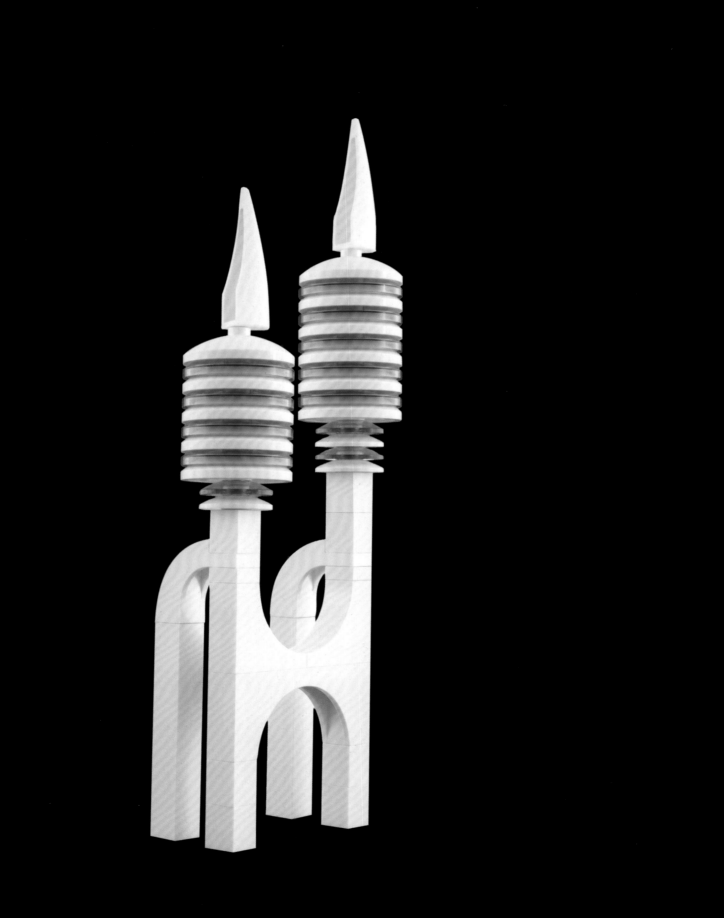

WATER STRIDER

The Water Strider's four legs give it the appearance of an abstract animal that may wander off at any moment.

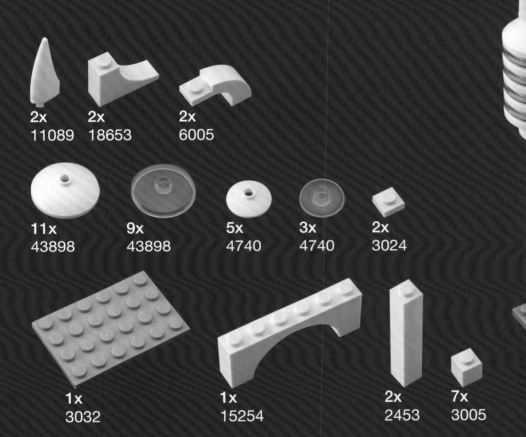

2x 11089	2x 18653	2x 6005

11x 43898	9x 43898	5x 4740	3x 4740	2x 3024

1x 3032	1x 15254	2x 2453	7x 3005

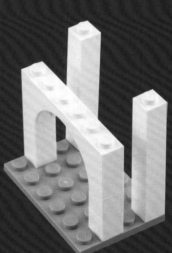

1

2x 4x

1x

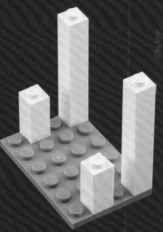

2

1x

3

4

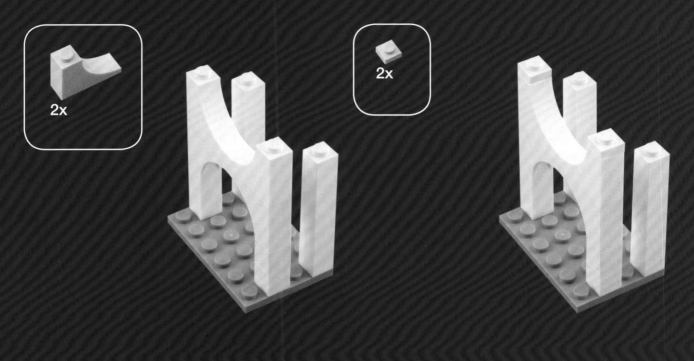

5

6

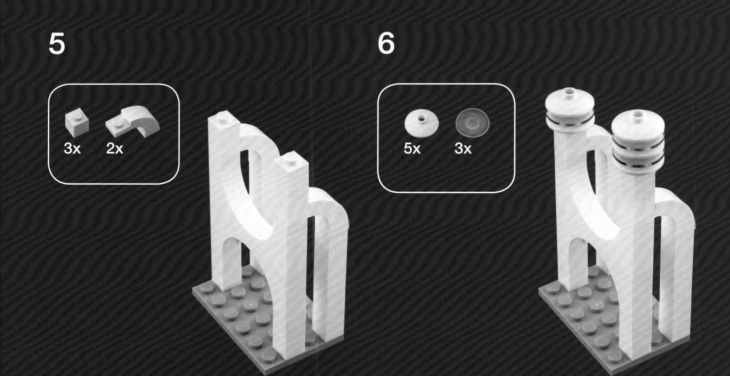

7

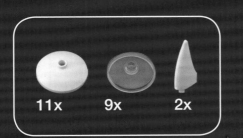

11x 9x 2x

MAKE IT YOUR OWN

The Water Strider is designed to arch over a river. You can use solid blue plates instead of transparent ones to represent the water.

Customize the landscape design with just a few common bricks.

4073 33291

3024 3023

54200 3023

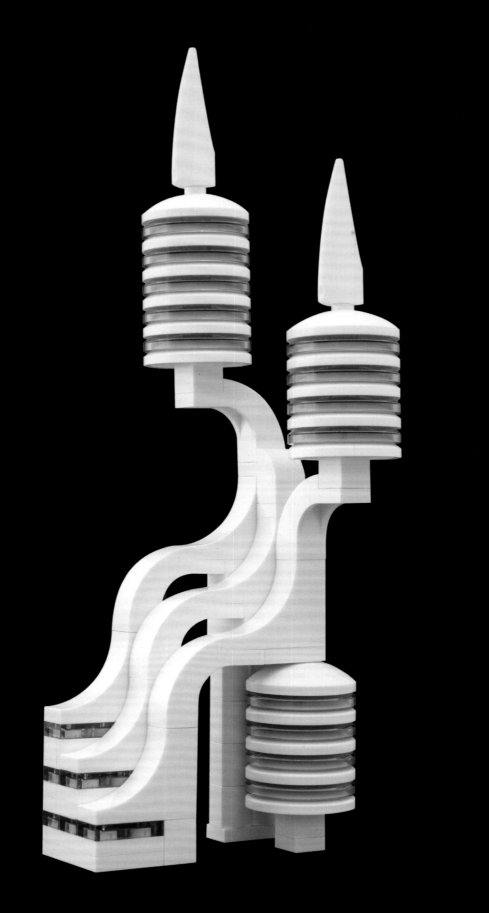

THE WAVELENGTH

The Wavelength building features indoor ski runs between the residential quarters and the office sector. No one ever complains about the commute here.

Stay ahead of the curve by building this unexpected LEGO form.

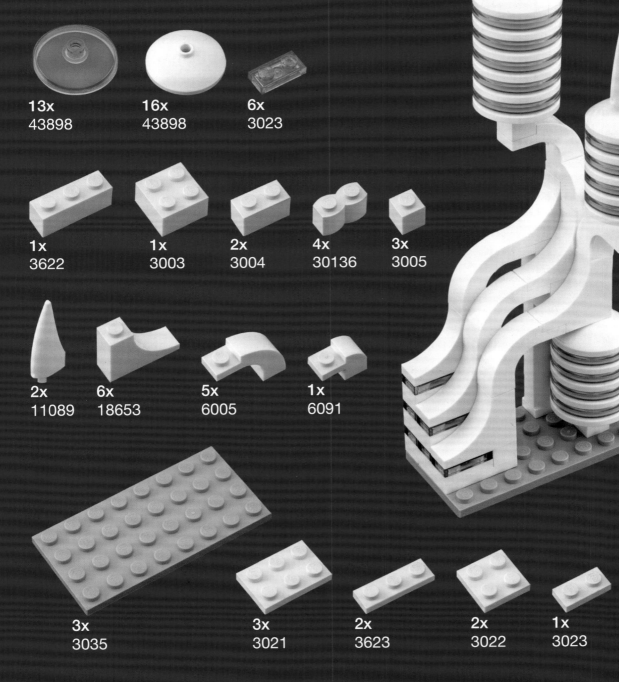

13x
43898

16x
43898

6x
3023

1x
3622

1x
3003

2x
3004

4x
30136

3x
3005

2x
11089

6x
18653

5x
6005

1x
6091

3x
3035

3x
3021

2x
3623

2x
3022

1x
3023

2x
3024

1

1x 1x 1x

2

4x 1x

3

4x 5x

4

1x

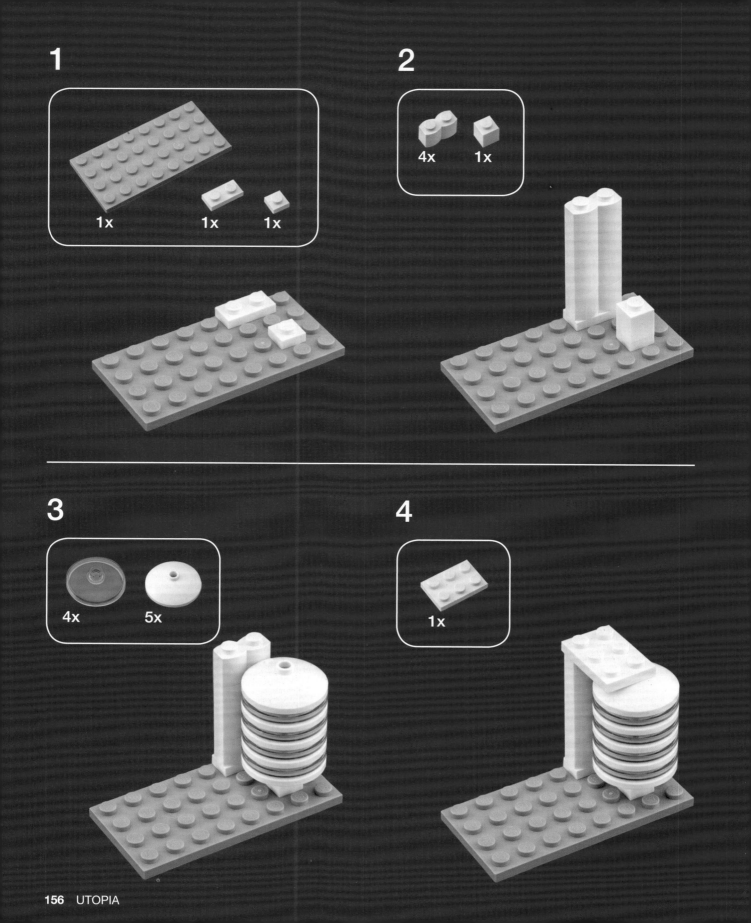

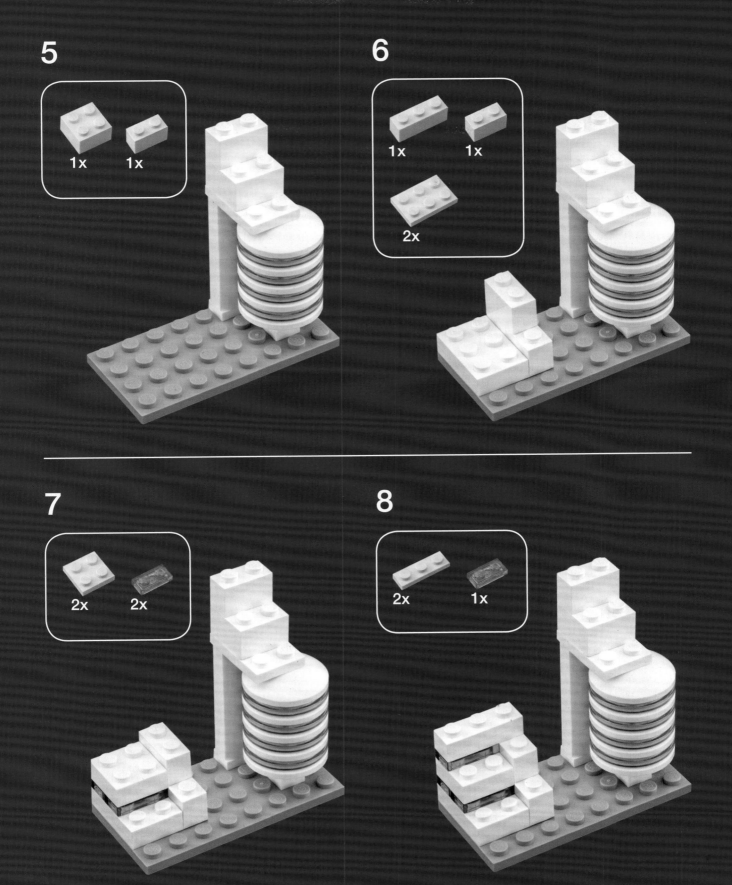

5

1x 1x

6

1x 1x

2x

7

2x 2x

8

2x 1x

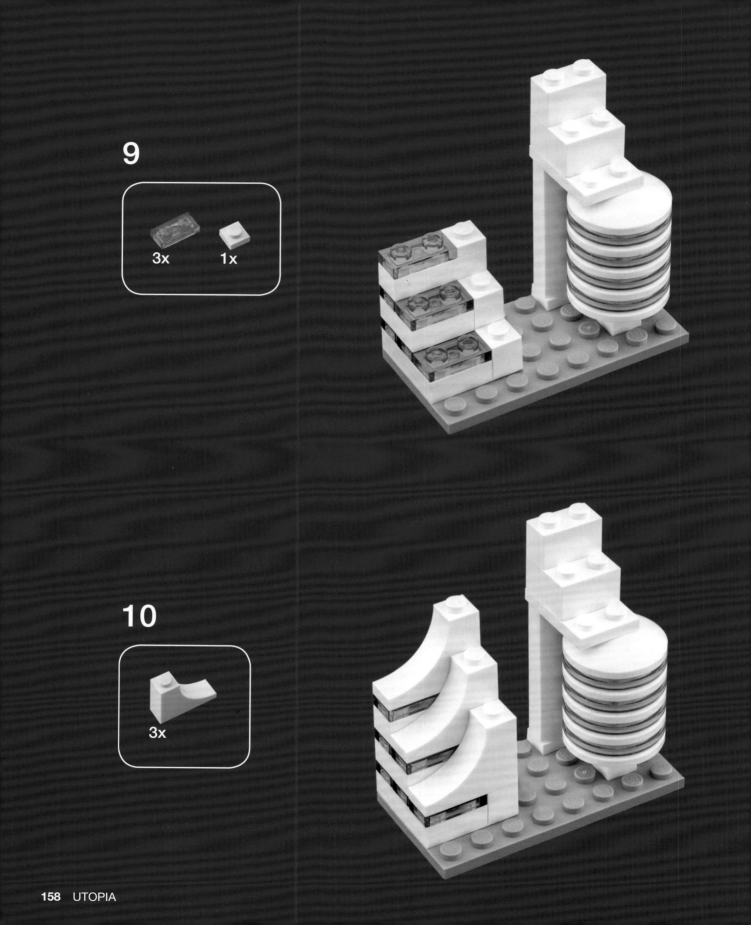

9

3x 1x

10

3x

11

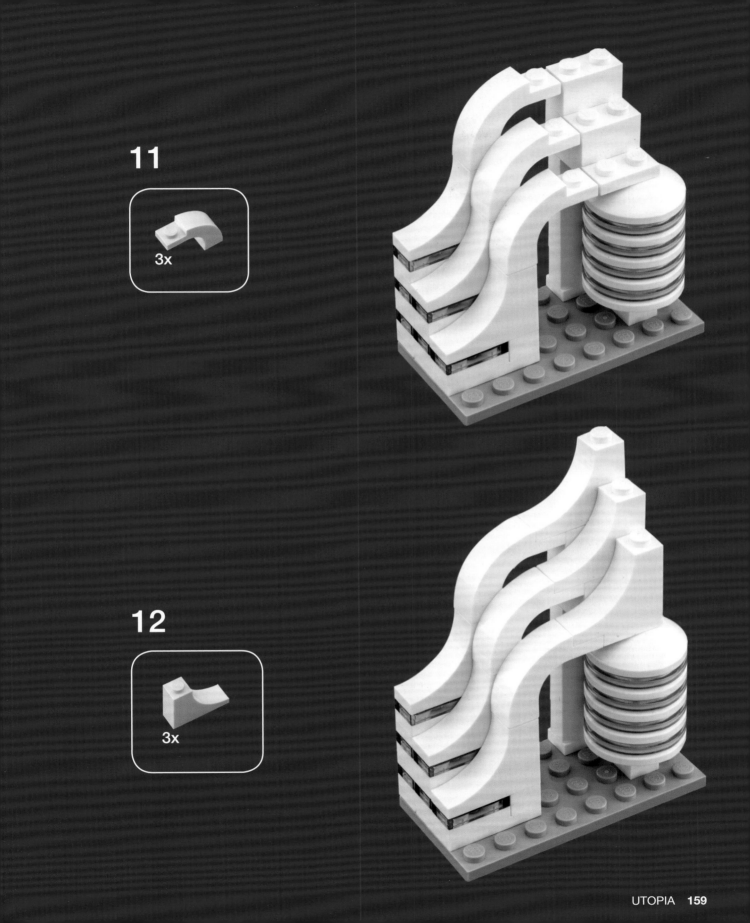

3x

12

3x

13

1x 1x

14

1x 1x

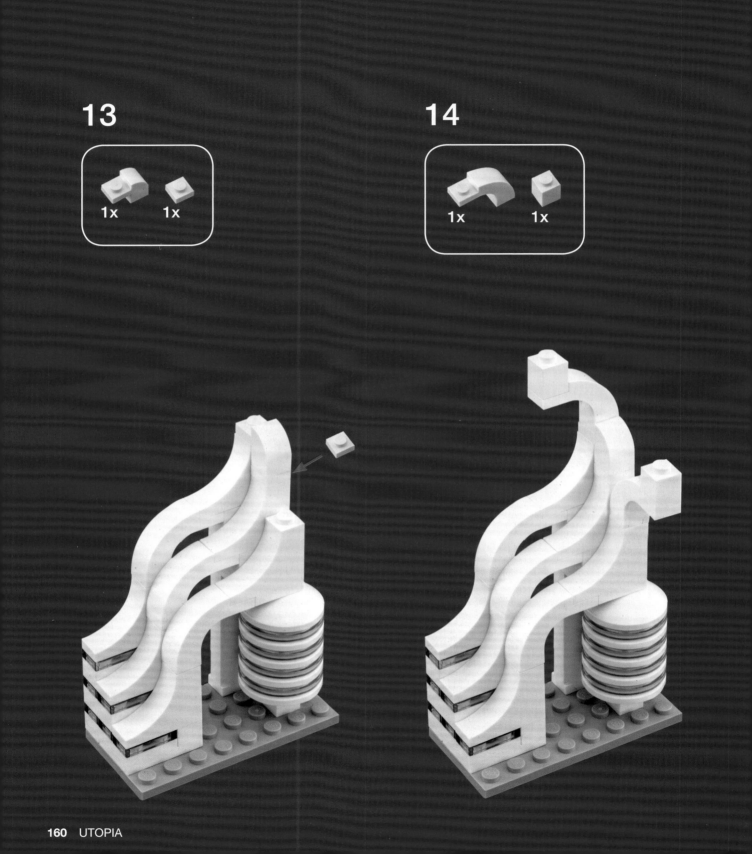

15

2x 9x 11x

When you attach the dish stacks, be sure to support the arches from below with your hand to avoid breaking anything.

MAKE IT YOUR OWN

The Wavelength's smooth architecture is purposely free of ornamentation to accentuate its aerodynamic shape. The building's top sail, however, offers room for personalization.

87747 13564

4592 24946 11610

3957

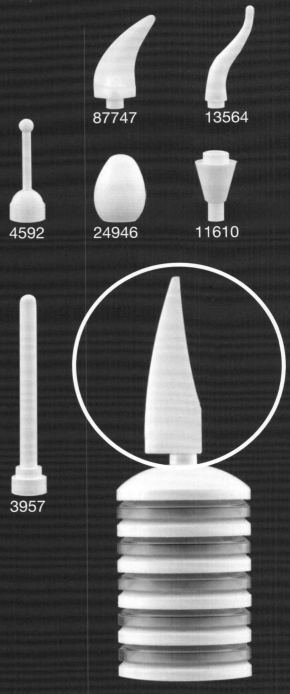

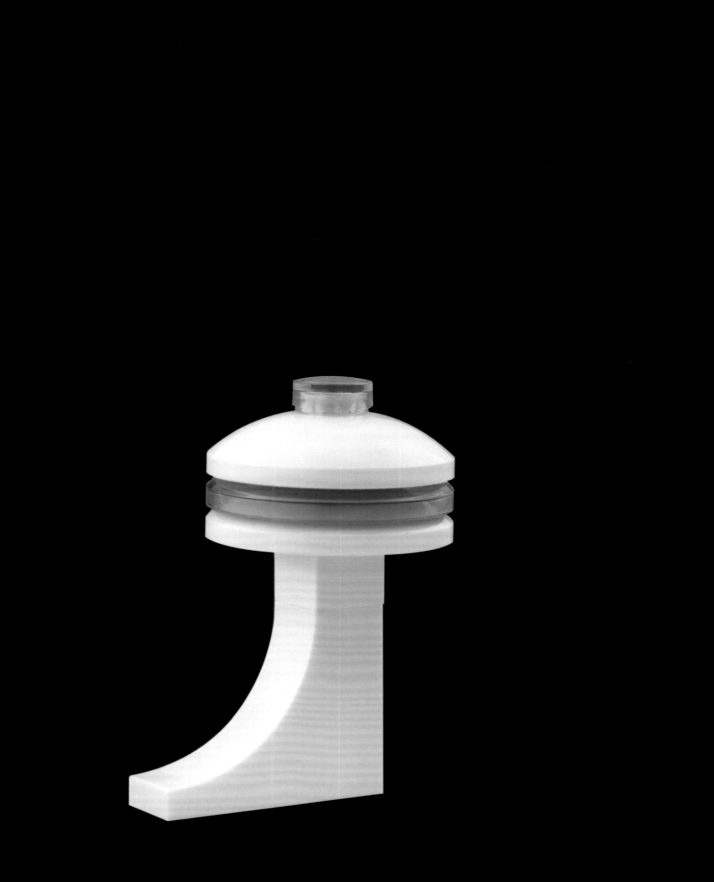

FLOATING FLATS

This building's disk section can detach from its base during earthquakes and hover like a flying saucer, virtually eradicating casualties. Six bricks are all you need for this beautifully simple design.

2x
43898

1x
43898

1x
18653

1x
3005

1x
98138

1

1x 1x

2

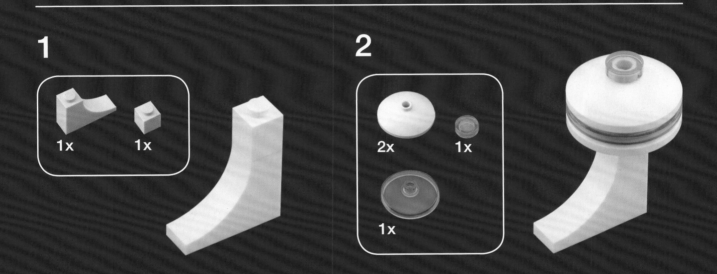
2x 1x

1x

MAKE IT YOUR OWN

You can fill a whole city with variations of these buildings using five bricks or fewer. The only pieces you may need to maintain harmony in design are the inverted arch and the dishes.

3622

4740

4740

3023

3024

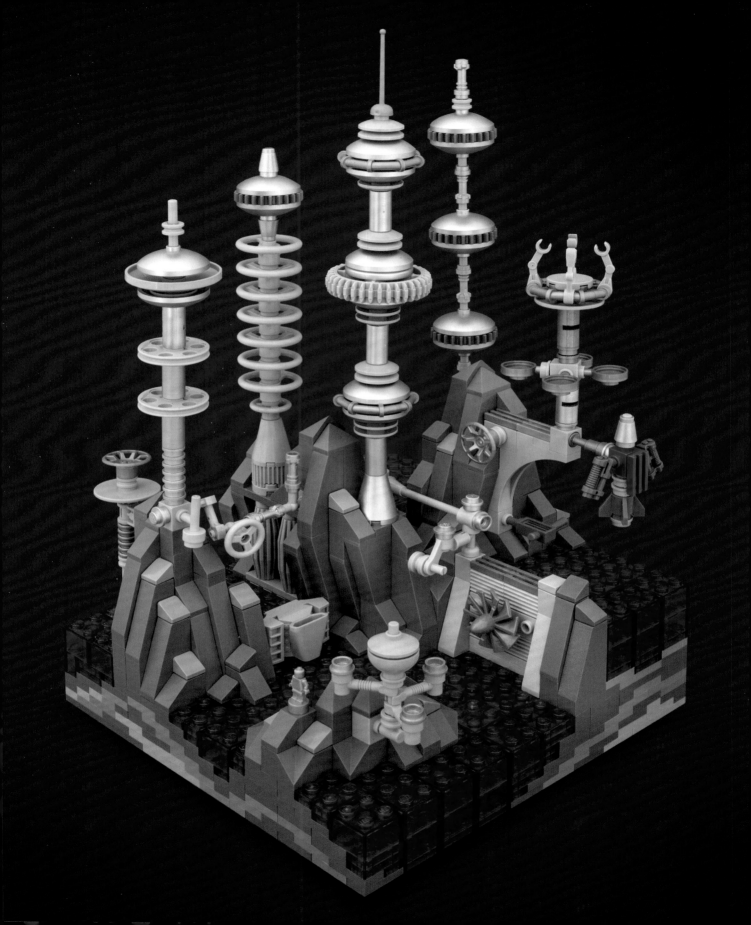

STRANGE NEW WORLDS

Fictional space colonies have been illustrated with soaring spires since the early days of science fiction. Is there a practical purpose for the spires, or are they a metaphor for reaching for the stars?

It is human nature to explore, and that includes exploring novel ways of LEGO building. Eventually, you might want to leave Earth-bound cities behind and construct a new colony somewhere in the cosmos.

Inhabiting new planets can bring new constraints and freedoms alike for city architecture. Low gravity means you can build taller structures without having them topple over. Dangerous cosmic rays may require reflective surfaces to protect your colonists. Alien invaders may need to be placated with fresh cookies from robotic bakeries. You can invent the problems and solutions for your new world.

This LEGO micro city involves pushing round elements through LEGO's 4-stud-long bar element. The building style doesn't rely on attaching studs to one another, so you can have two pieces of the same type sandwiched together with studs facing opposite directions.

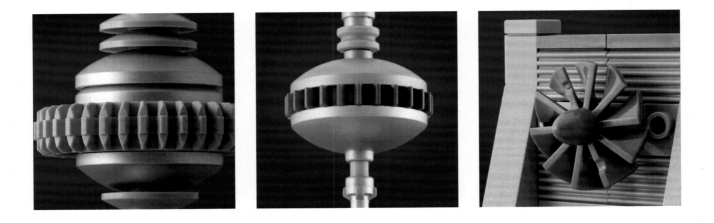

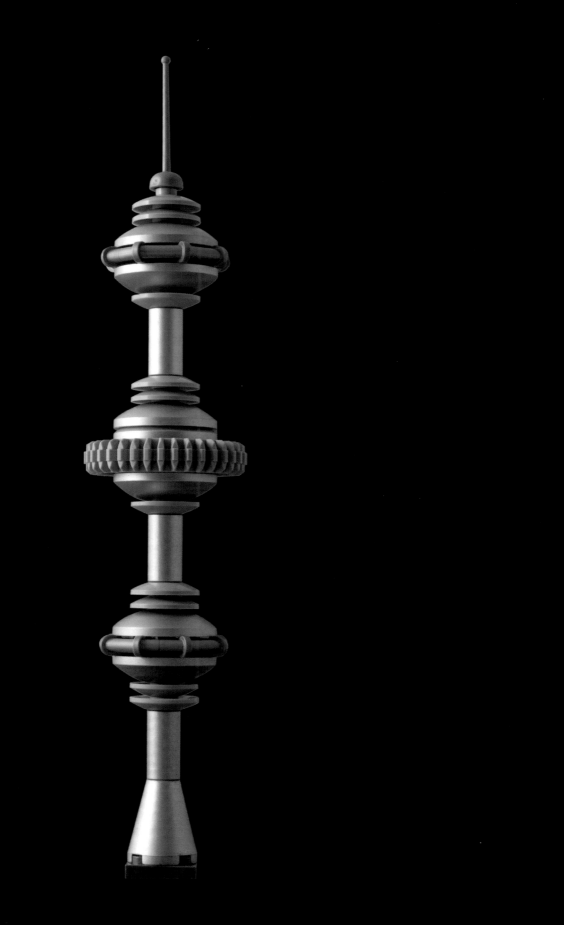

GALAXY SPIRE

The Galaxy Spire's antenna transmits broadband Wi-Fi to every corner of the planet, ensuring that new colonists won't miss out on baby panda live streams from Earth.

Although the Galaxy Spire uses advanced building techniques, it's easy to customize with your own module designs.

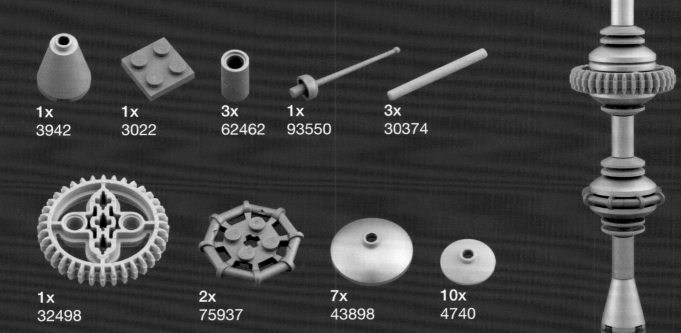

1x
3942

1x
3022

3x
62462

1x
93550

3x
30374

1x
32498

2x
75937

7x
43898

10x
4740

1

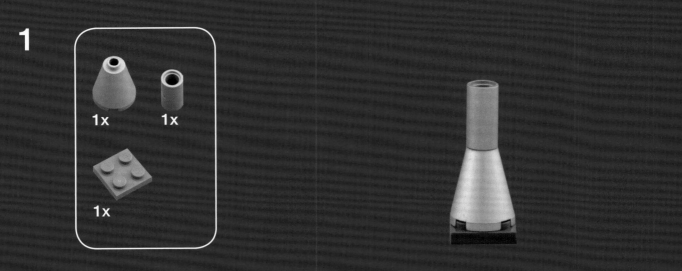

1x 1x

1x

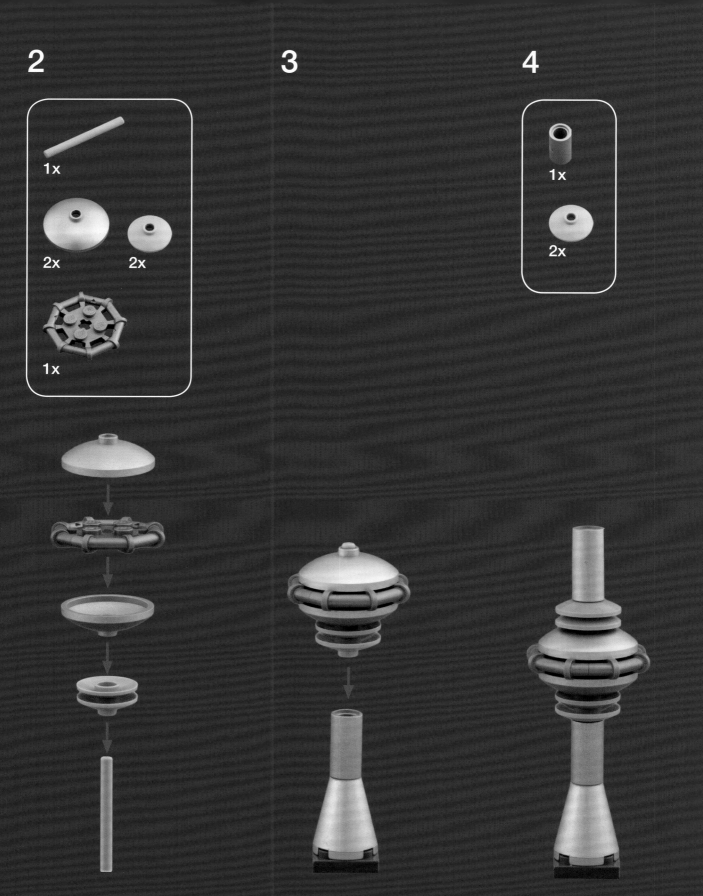

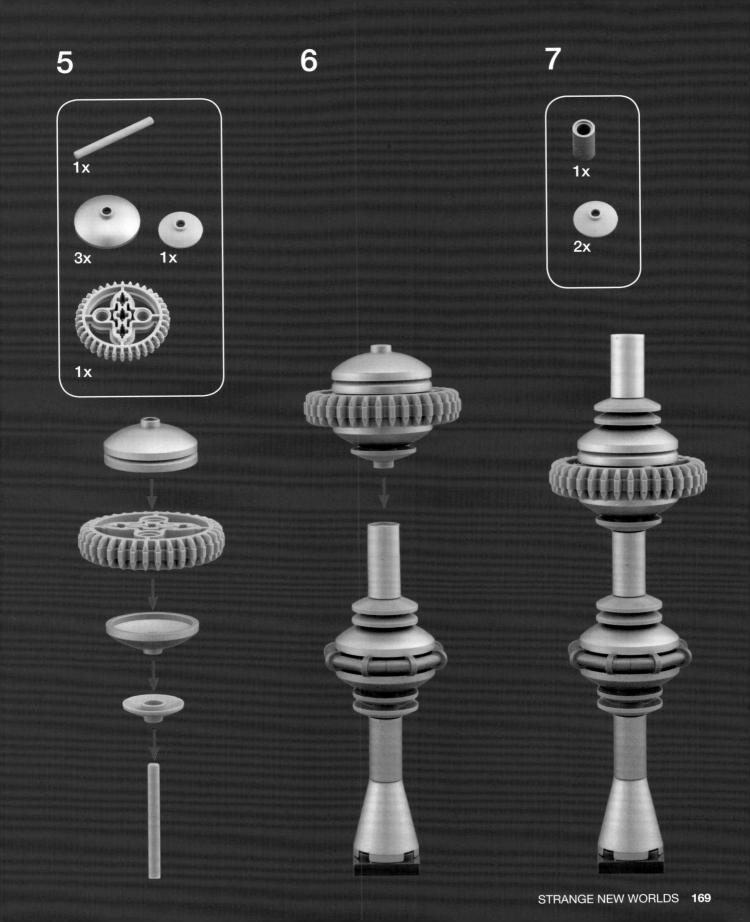

5

1x

3x 1x

1x

6

7

1x

2x

8 **9** **10**

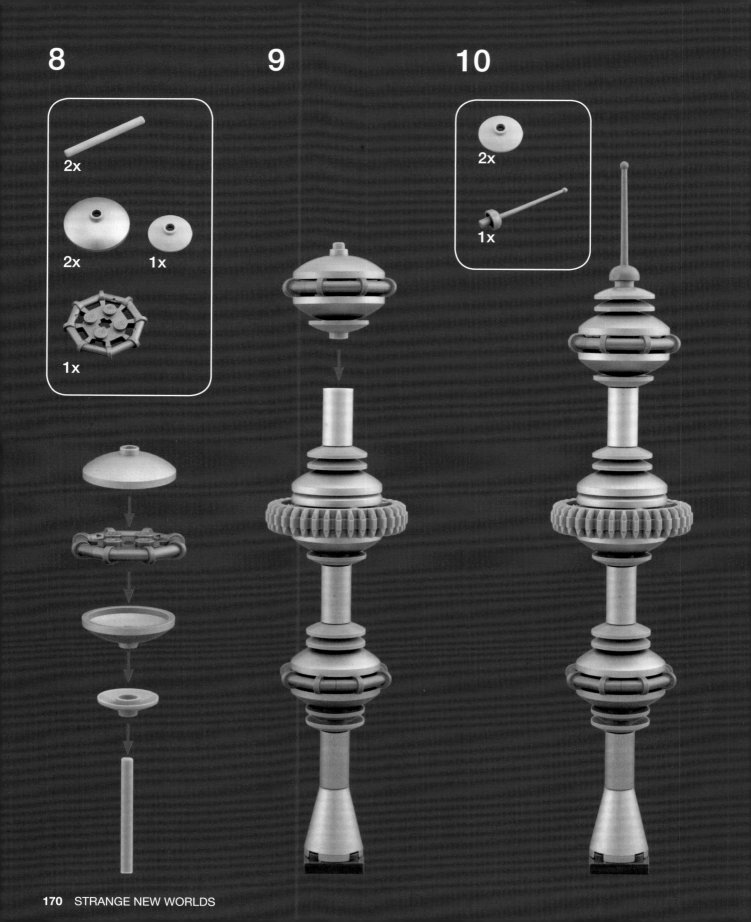

MAKE IT YOUR OWN

Many round LEGO elements have an axle hole or round hole in the center. You can push a LEGO bar through these pieces to hold them in place.

BUILD A DISH SANDWICH!

In a dish sandwich, dishes are the bread, and the bar is the toothpick holding the ingredients together. The filling is any LEGO element that can fit onto a bar. Here are some examples of tasty "fillings" you can add to your dish sandwich.

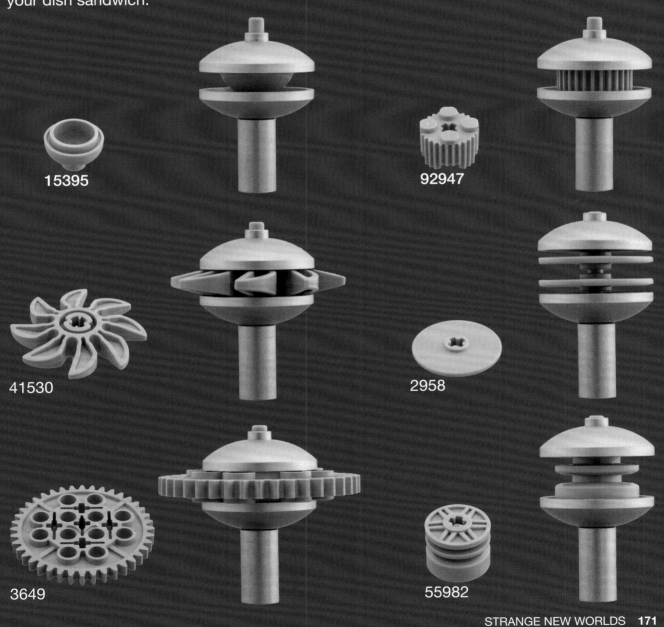

15395

92947

41530

2958

3649

55982

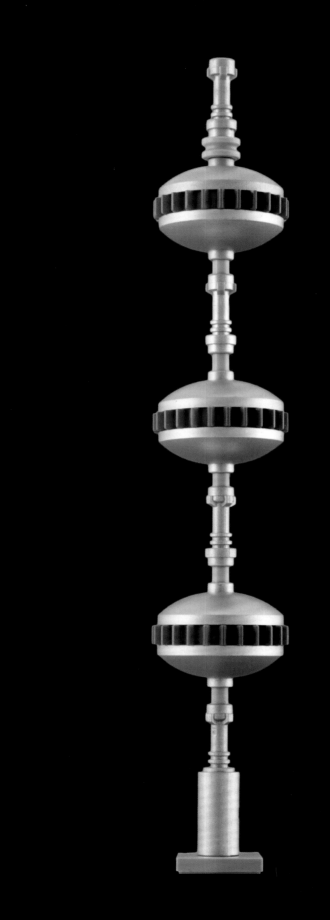

INTERPLANETARY PODS

Interplanetary Pods are a modular living system designed for quick assembly and efficient transfer of gossip between pods.

Use the Force—or lightsaber handles—to hold the pods together.

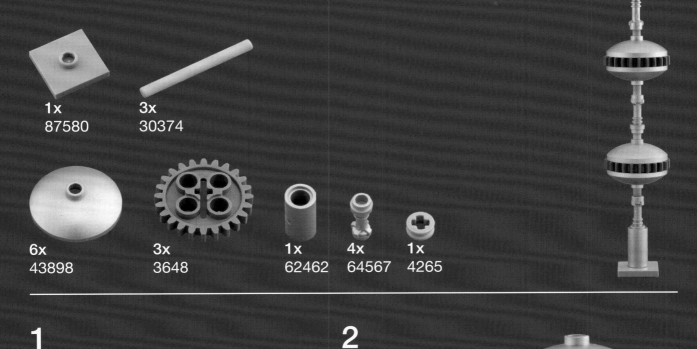

1x 87580

3x 30374

6x 43898

3x 3648

1x 62462

4x 64567

1x 4265

1

1x **1x**

1x

2

1x

2x

1x

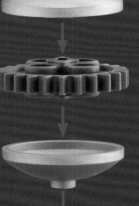

3x

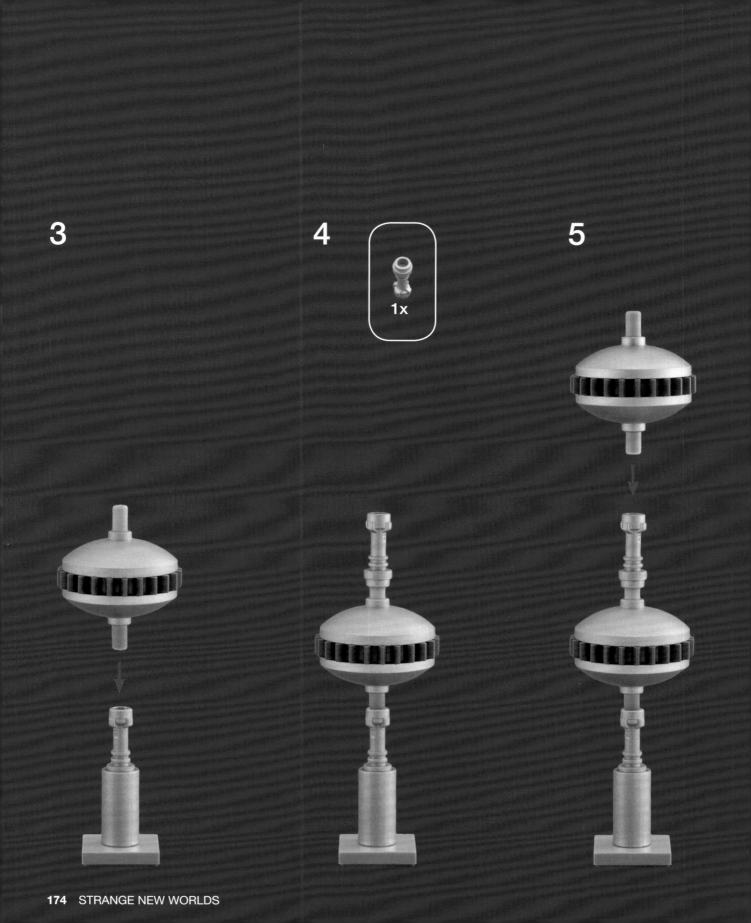

3

4

1x

5

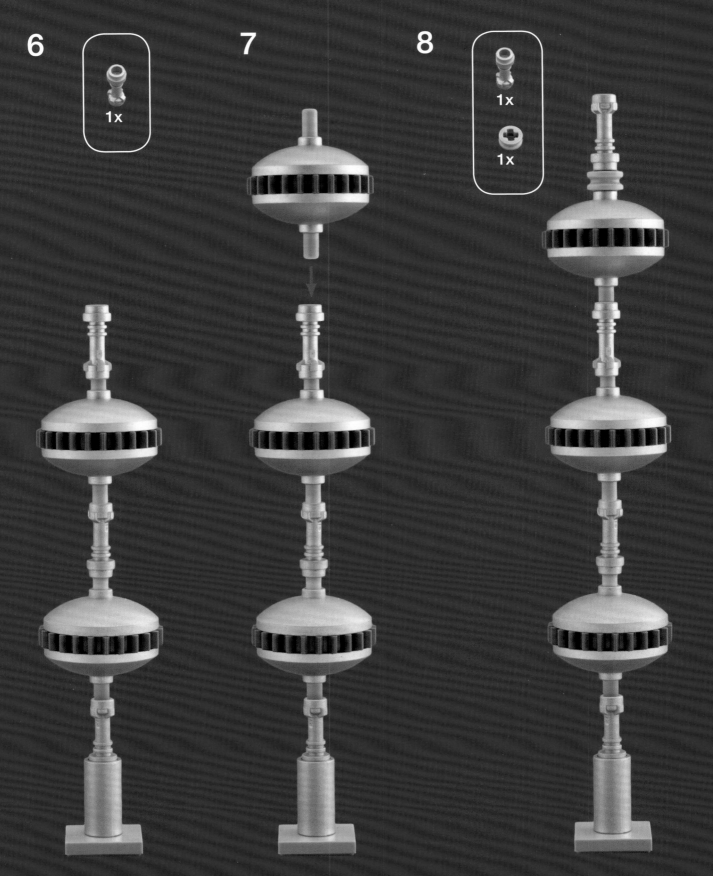

MAKE IT YOUR OWN

On page 171, you learned how to build
different modules using the dish sandwich
technique. Here are some ideal pieces
for customizing the space between those
modules.

3062b

2819

62462

4588

4740

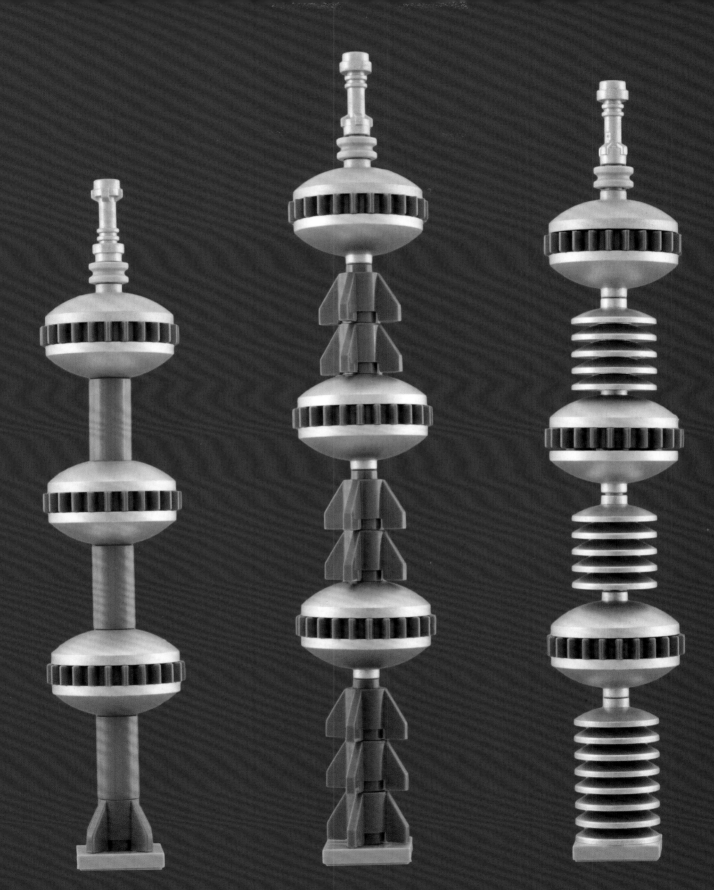

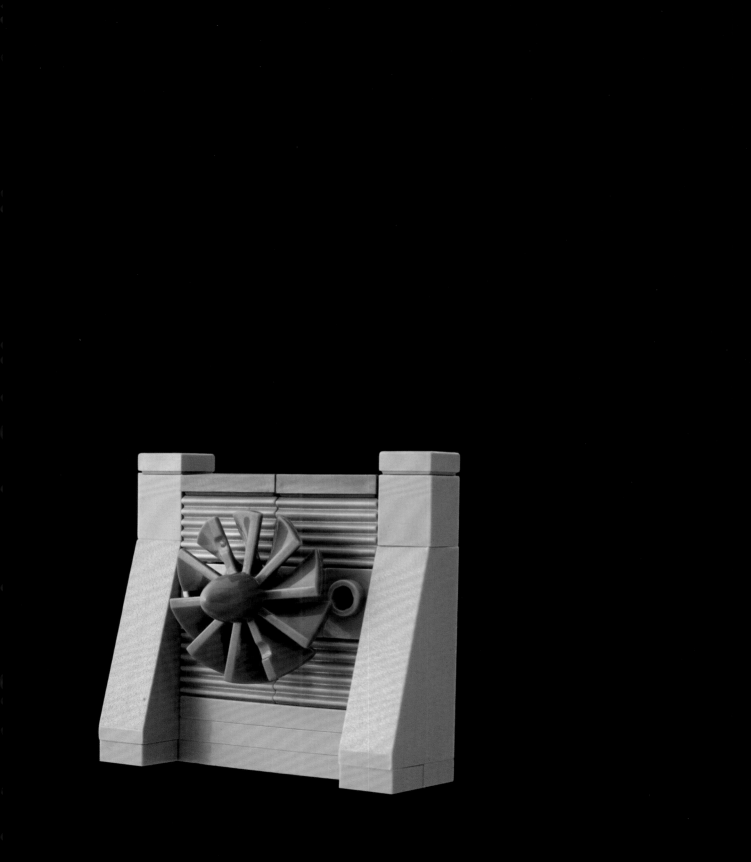

HYDRO DAM

Clean hydroelectricity never goes out of style. Just add water!

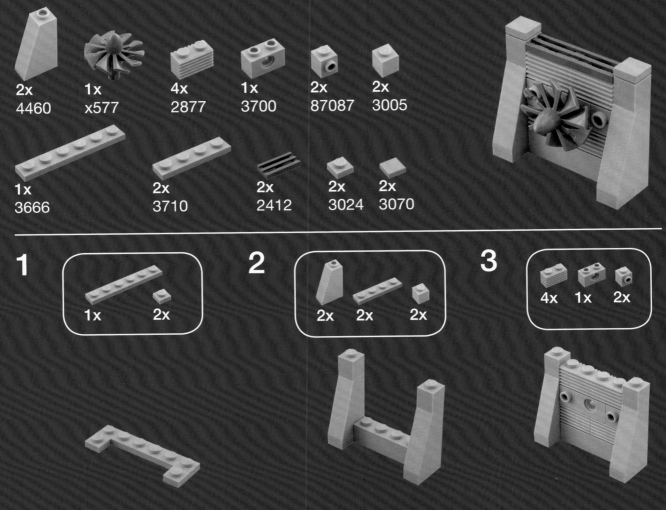

2x	1x	4x	1x	2x	2x
4460	x577	2877	3700	87087	3005

1x	2x	2x	2x	2x
3666	3710	2412	3024	3070

1
1x 2x

2
2x 2x 2x

3
4x 1x 2x

4
1x 2x 2x

MAKE IT YOUR OWN

Use Technic wheels and 1×1 round plates instead of the engine (part #x577) to change the appearance and perceived function of your dam.

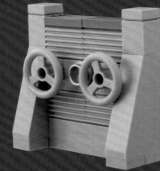

4073 30663

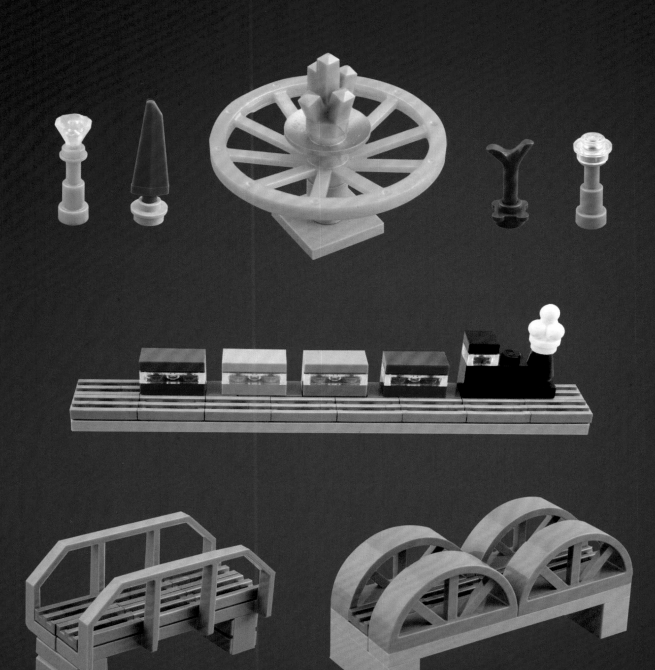
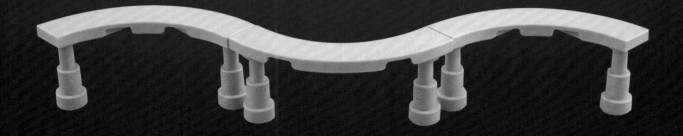

THE FINISHING TOUCH

Beauty is in the details. In every creative endeavor, what distinguishes great works from average ones is the attention to detail. Although you might consider trees, statues, and lampposts mere afterthoughts in your micro city design, these details are what transform your city into a cohesive and believable scene.

It doesn't take a lot of bricks to add these details to your city, but it does take careful thought. Making microscale city details is like being a sashimi chef: there are only a few ingredients, so there's little room for error. You have to distill the essence of a train, fountain, or small apartment building using bricks that could fit into an espresso cup.

Here are some ideas for adding beautiful details to your city.

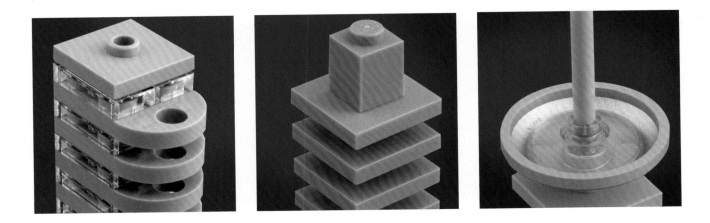

ROADS AND RAILS

LEGO tiles are available in a variety of lengths, and they all make excellent microscale roads. Use dark grey as asphalt, light grey as pavement, dark tan as gravel, and brown as dirt roads. For re-creating railroads, 1×2 grille tiles are the best. Grille tiles are not currently available in other lengths, but they come in grey, black, silver, and brown.

4162 6636 2431 3069 27507 27925 2412

ELEVATED ROADWAYS

You can raise your roadway by building it on top of supports, called *piers*. Rounded pieces make the most aesthetically pleasing piers in microscale.

4274 + 30136 64644 3062
62462

MONORAIL

Transport your citizens in style on an aerodynamic monorail. Use white tile pieces on an elevated roadway to make the monorail track.

 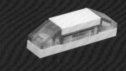

1x 1x 1x 2x
3710 3023 3069 54200

To attach your monorail car to the track, place a 1×4 plate somewhere along the monorail route. The car attaches to the plate as shown here, hiding the plate's studs.

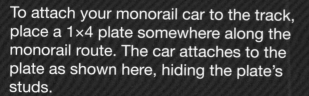

BRIDGES

You can make bridges in all shapes and sizes to suit your needs.

BRICK ARCH BRIDGE

1x
6182

1x
2431

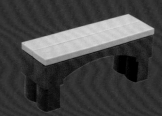

WOOD ARCH BRIDGE

2x
92950

2x
6636

2x
30136

TRUSS BRIDGE

2x
6583

2x
98283

6x
2412

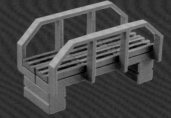

TIED-ARCH BRIDGE

4x
20309

2x
3622

4x
2412

1x
3034

1x
3460

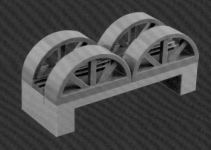

TRAINS

Steam trains add a sense of motion and industry to your city.

ENGINE

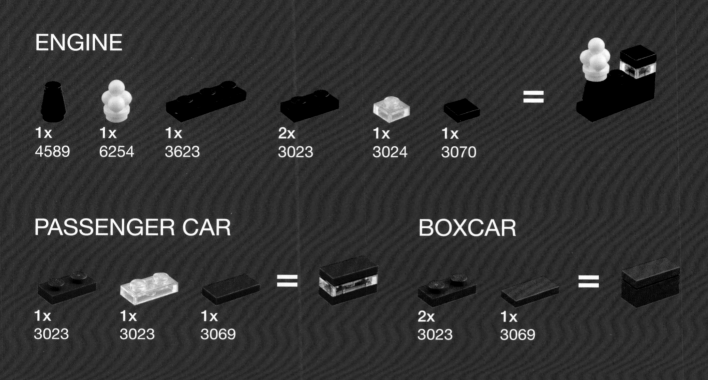

1x	1x	1x	2x	1x	1x
4589	6254	3623	3023	3024	3070

PASSENGER CAR

1x	1x	1x
3023	3023	3069

BOXCAR

2x	1x
3023	3069

PLACING A TRAIN ON THE TRACKS

Microscale trains look best with a half-stud gap between the cars. You can achieve this by repeating a pattern of 1×2 plates, 1×1 tiles, and 1×2 jumper plates as shown.

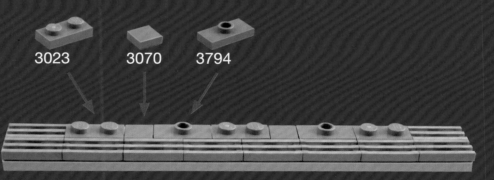

3023 3070 3794

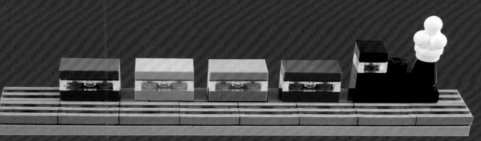

SHIPS

Decorate your sea and sky with microscale ships from any era.

SAILBOAT

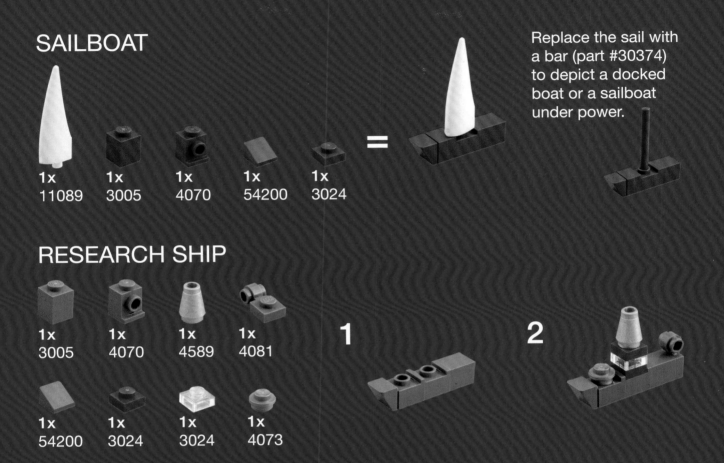

1x
11089

1x
3005

1x
4070

1x
54200

1x
3024

=

Replace the sail with a bar (part #30374) to depict a docked boat or a sailboat under power.

RESEARCH SHIP

1x
3005

1x
4070

1x
4589

1x
4081

1x
54200

1x
3024

1x
3024

1x
4073

1

2

SPACESHIP

When your spaceship returns from its mission, it can be docked with one of the two open studs on the blue fuselage, as shown on page 164.

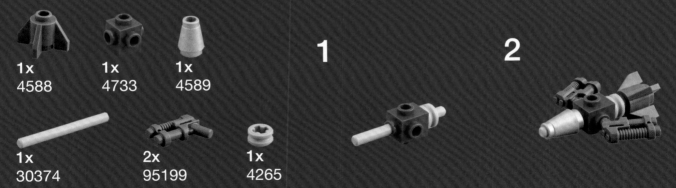

1x
4588

1x
4733

1x
4589

1

2

1x
30374

2x
95199

1x
4265

LANDSCAPING

You can make convincing shrubs and bushes by stacking regular green 1×1 round plates and green 1×1 round plates with a flower edge (part #33291). Mix and match the plates at varying heights and in different shades of green to make the landscape design your own.

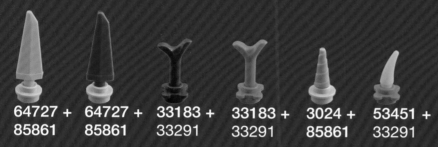

3x	2x	33291 +	1x
4073	4073	3024	4073

64727 +	64727 +	33183 +	33183 +	3024 +	53451 +
85861	85861	33291	33291	85861	33291

Combine open stud pieces with the stem pieces that fit into them to simulate coniferous and deciduous trees.

IN THE PARK

Lampposts and footbridges complement natural features.

30153 +
64644

4073 +
64644

Brighten your city parks at night with decorative lighting.

93273

This single piece becomes a footbridge. Use different colors to represent stone, wood, or brick.

STATUES

Honor your city's founder with fine sculptures.

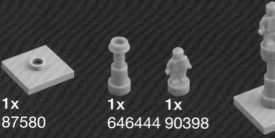

1x
87580

1x
646444

1x
90398

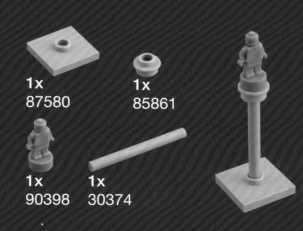

1x
87580

1x
85861

1x
90398

1x
30374

FOUNTAINS

Fountains can do a lot to freshen up an urban environment and make your citizens happy.

BOWL FOUNTAIN

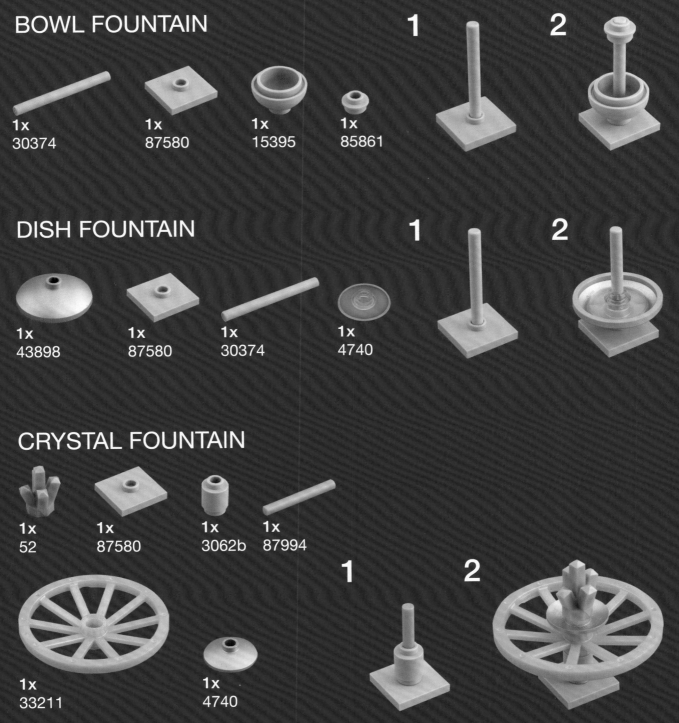

1x
30374

1x
87580

1x
15395

1x
85861

1

2

DISH FOUNTAIN

1x
43898

1x
87580

1x
30374

1x
4740

1

2

CRYSTAL FOUNTAIN

1x
52

1x
87580

1x
3062b

1x
87994

1x
33211

1x
4740

1

2

THREE-BRICK BUILDINGS

You can use small buildings made with just three brick types to fill out small spaces between your feature buildings and establish a sense of scale.

SMALL FOOTPRINT

1x
15470

4x
3024

3x
3024

PORTHOLES

3x
47905

6x
98138

1x
22388

BASIC STRUCTURE

5x
3023

5x
3023

1x
3069

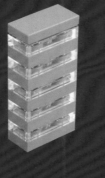

TERRACES

3x
3024

4x
87580

1x
3005

FUTURISTIC TOWER

1x
98138

3x
4740

4x
4740

OFFICES

1x
3794

3x
2877

3x
3023

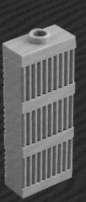

GRILLE WINDOWS

3x
2412

3x
11211

2x
54200

CURVES

10x
3023

5x
3176

1x
87580

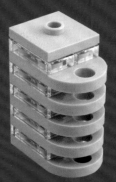

DOME

1x
3022

1x
92947

1x
553

TALL WINDOWS

2x
15571

3x
3022

4x
30136

POSTMODERN DESIGN

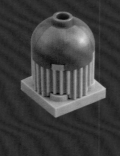

1x
98138

1x
3022

9x
87580

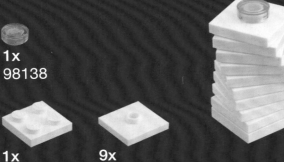

Rotate each 2×2 jumper plate slightly clockwise as you build upward. Use a regular 2×2 plate for the bottom floor.

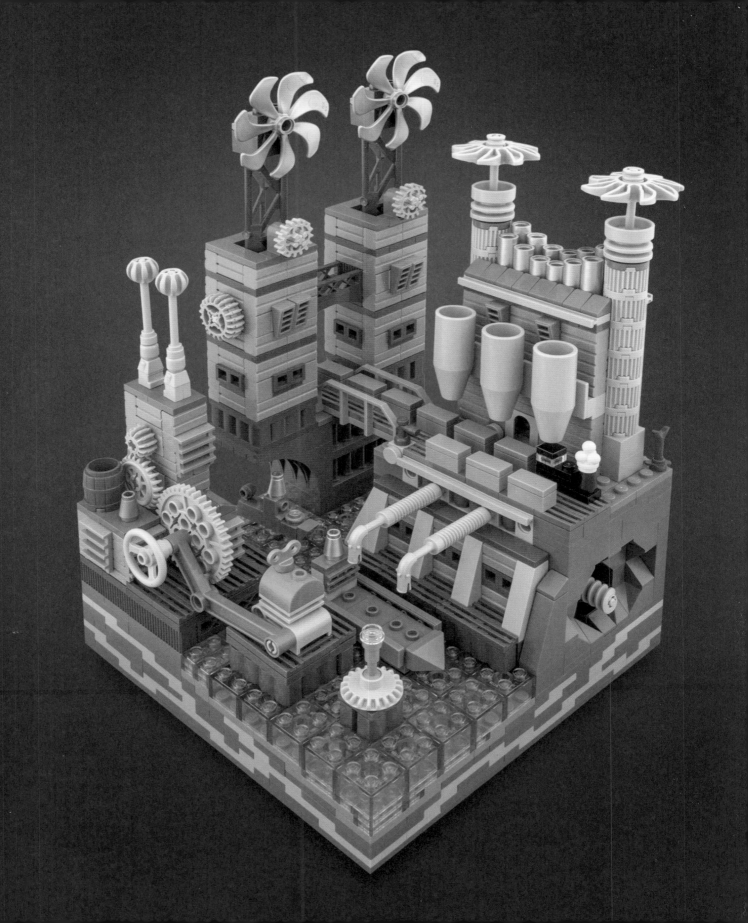